Frida Kahlo

Andrea Kettenmann

FRIDA KAHLO
1907–1954

Pain and Passion

Benedikt Taschen

FRONT COVER:
Self-portrait with Monkey (detail), 1938
Oil on masonite, 40.6 x 30.5 cm
Buffalo (NY), Albright-Knox Art Gallery,
Bequest of A. Conger Goodyear, 1966
(cf. ill. p. 44)

ILLUSTRATION PAGE 1:
Frida in Coyoacán (detail), around 1927
Pencil on paper, 10.5 x 14.8 cm
Tlaxcala, Instituto Tlaxcalteca de Cultura

FRONTISPIECE AND BACK COVER:
Frida Kahlo, around 1939
Photograph: Nickolas Muray
Rochester (NY), International Museum of
Photography at George Eastman House

**This book was printed on 100 % chlorine-free bleached
paper in accordance with the TCF standard.**

© 1993 Benedikt Taschen Verlag GmbH
Hohenzollernring 53, D-50672 Köln
Reproductions with the kind permission of
the Instituto Nacional de Bellas Artes, Mexico City
Editors and production: Sally Bald, Angelika Muthesius, Cologne
Picture research: Frigga Finkentey, Cologne
Cover design: Angelika Muthesius, Cologne
English translation: Karen Williams, London

Printed in Germany
ISBN 3-8228-9636-5
GB

Contents

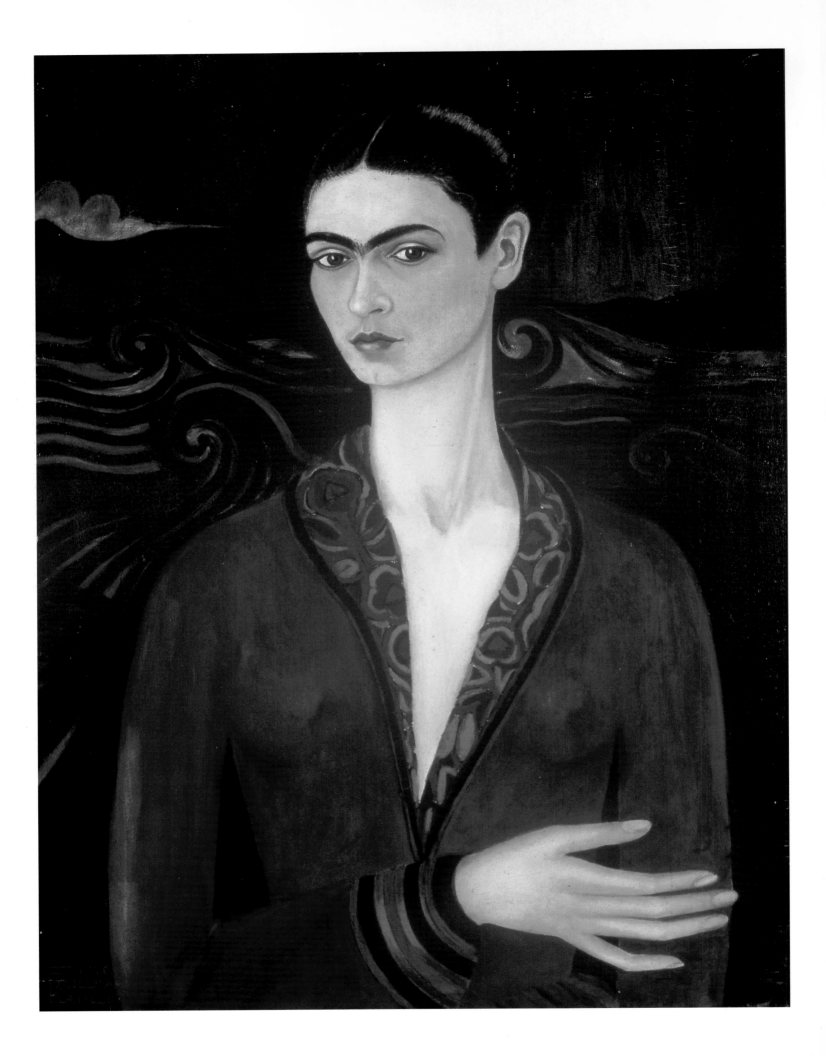

"Peg-leg Frida" – a rebellious girl

"I remember that I was four [actually, she was five] years old when the 'tragic ten days' took place. I witnessed with my own eyes Zapata's peasants' battle against the Carrancistas."[1]

With these words Frida Kahlo (1907–1954), writing in her diary in the early 1940s, described her memories of the Decena Trágica, the "tragic ten days" of February 1913. Indeed, her identification with the Mexican Revolution (1910–1920) was so strong that she always gave the year of her birth as 1910. Following the colonial era and the thirty-year dictatorship of General Porfirio Díaz, the Revolution aimed to effect fundamental changes in the country's social structure. Frida Kahlo apparently decided that she and the new Mexico were born at the same time. In truth, however, she was three years the elder: Magdalena Carmen Frieda Kahlo Calderón was born on 6 July 1907 in Coyoacán, then a suburb of Mexico City, as the third of four daughters born to Matilde and Guillermo Kahlo.

In *My Grandparents, My Parents and I* (ill. p. 9), painted in 1936, the artist traces the history of her ancestry. She appears as a little girl standing in the garden of the Blue House in Coyoacán, today the Museo Frida Kahlo (ills. p. 88/89), in which she was born and was also to die. Her parents, who built the house in 1904, appear above her in a pose copied from a photograph taken on their wedding day in 1898 (ill. p. 8 above). The artist points to her prenatal existence in the foetus shown in her mother's womb. In the motif of the pollination of a flower on the left, she traces her life right back to the moment of conception. In her right hand Frida holds a red ribbon: its two ends wind around her parents and lead up to her two sets of grandparents, their portraits growing out of a bed of cloud. Her maternal grandparents are shown hovering over a mountainous Mexican landscape and a nopal, a type of cactus which features in the myth of the foundation of the state of Mejica and is found in symbolic form on the Mexican flag, and which effectively represents the national plant of Mexico. Frida Kahlo's mother, Matilde Calderón y González (1876–1932), was born in Mexico City as the daughter of Isabel González y González, who came from the family of a Spanish general, and the photographer Antonio Calderón, who was of Indian descent.

The artist's paternal grandparents float above the sea: they come from the far side of the ocean. Wilhelm Kahlo (1872–1941), Frida's

Frida Kahlo, photographed in 1926 by her father, Guillermo Kahlo (1872–1941).

Self-portrait in a Velvet Dress, 1926
This self-portrait is Frida Kahlo's first serious work. It was painted as a gift for her student boyfriend, Alejandro Gómez Arias, who had left her and whom she thereby hoped to win back. The aristocratic pose reflects Frida Kahlo's interest in the painting of the Italian Renaissance, while the mannerist elongation of the neck recalls works both by Parmigianino and Amedeo Modigliani.

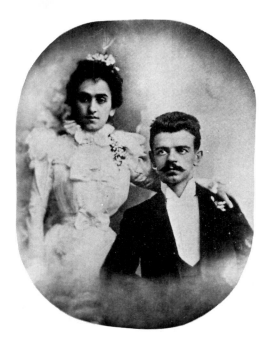

Wedding photograph of Frida Kahlo's parents, Matilde Calderón and Guillermo Kahlo, taken in February 1898.

Portrait of Frida's Family, around 1950–54
Frida Kahlo worked regularly on this family tree during a long spell in hospital in 1950, but the picture was to remain unfinished. In addition to her parents and grandparents, the artist depicts her sisters, her niece and nephew, and another, unidentified child.

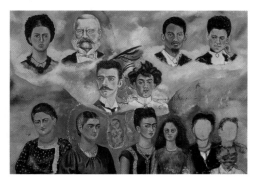

father, was born in Baden-Baden, Germany, as the son of the jeweller and goldsmith Jakob Heinrich Kahlo and his wife Henriette, née Kaufmann. Both were Hungarian Jews who had emigrated to Germany and achieved prosperity there. Following the death of his mother and his father's remarriage, in 1891 the nineteen-year-old Wilhelm Kahlo sailed for Mexico, his passage paid with money given him by his father. There he changed his German forename for its Spanish equivalent, Guillermo, and found employment in a succession of different fields. After his first wife died giving birth to their second daughter, he married Matilde Calderón. His daughters from his first marriage were sent away to be brought up in a convent. From his new father-in-law Kahlo now learned the art of photography, in order to set himself up in business as a professional photographer.

In a second version of this "family tree", the *Portrait of Frida's Family* begun in the early 1950s and left unfinished at her death (ill. p. 8 below), the artist also includes her sisters: Matilde (1898–1951) and Adriana (1902–1968) on one side, and Cristina (1908–1964) between her two children Isolda (1929) and Antonio (1930–1974) on the other. Amongst these figures at the bottom of the picture there also appears another, unidentified child.

During the rule of the dictator Díaz, Guillermo Kahlo was commissioned to compile a photographic inventory of the architectural monuments of the pre-Columbian and colonial eras. His pictures were to illustrate large-format books published in luxury editions and planned to coincide with the centenary celebrations of Mexican independence in 1921. Guillermo Kahlo was chosen for the project thanks to his experience as an architectural photographer; he thereby earned the appellation "first official photographer of Mexico's national cultural patrimony".

The Mexican Revolution brought an abrupt end to this lucrative commission. "It was with great difficulty that a livelihood was earned in my house"[2], the artist later recalled, and it was for this reason that she used to work in shops after school even as a child, in order to supplement her family's meagre income.

In a conversation with art critic Raquel Tibol, the artist described details of her childhood: "My mother was unable to breast-feed me because my sister Cristina was born just eleven months after I was. I was fed by a wet-nurse, whose breasts were washed immediately before I was suckled. In one of my pictures I show myself, with the face of a grown woman and the body of a little girl, in the arms of my nurse, milk dripping from her breasts as from the heavens." The work in question is *My Nurse and I* of 1937 (ill. p. 47). The Indian wet-nurse, naked from the waist up, wears a pre-Columbian Teotihuacan stone mask in place of a face. Her figure, which recalls representations of indigenous mother goddesses and the wet-nurse figures of the grave art of Jalisco, also refers to the colonial, Christian motif of the Madonna and Child. In fusing these two different traditions, the nurse becomes a symbol of the artist's own mestiza origins. But whereas Western images of the Madonna and Child express the

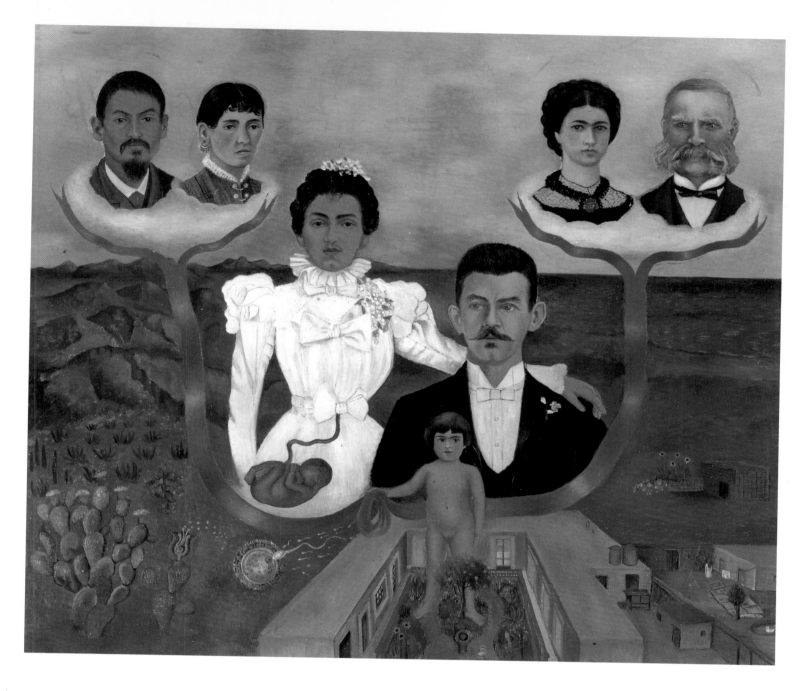

affection and intimacy binding mother and infant, the relationship shown here is distanced and cool, an impression heightened by the lack of eye contact. Although the baby is being fed, tenderness and loving care are not on the menu. "Since Kahlo's wet-nurse was employed solely for breastfeeding, she probably had no personal bond with Kahlo the baby. Thus it is likely that breastfeeding proceeded exactly as Kahlo has painted it: lacking in all emotion."[3] This lack of emotional bond no doubt helps to explain Frida's ambivalent feelings towards her mother, whom she described as very kind, active and intelligent, but also as calculating, cruel and fanatically religious.

Her father, on the other hand, she described as warm and affectionate: "My childhood was marvelous", she wrote in her diary, "because, although my father was a sick man (he had vertigos every month and a half), he was an immense example to me of tenderness, of work (photographer and also painter) and above all of understand-

My Grandparents, My Parents and I, 1936
This work traces the history of Frida Kahlo's ancestry. The artist is depicted as a little girl aged about three. The portraits of her parents are based on their wedding photograph of 1898. Her maternal, Mexican grandparents are symbolized by the land, while her paternal, German grandparents are symbolized by the ocean.

9

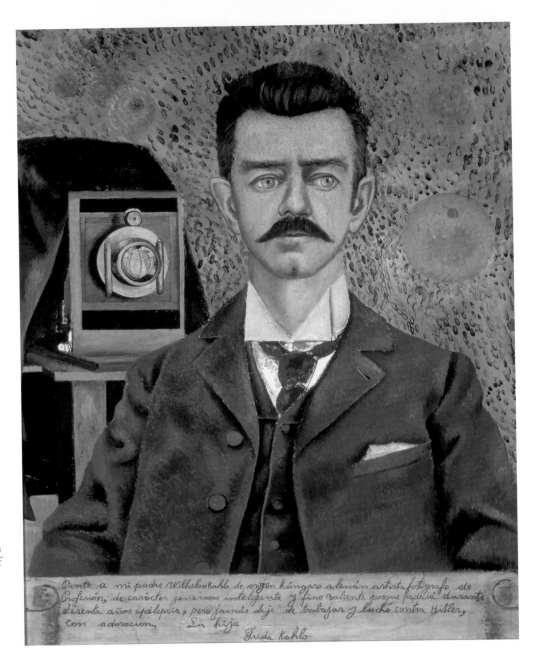

Portrait of My Father, 1951
The dedication in the banderole at the bottom reads: "I painted my father Wilhelm Kahlo, of Hungarian-German origin, artist-photographer by profession, in character generous, intelligent and fine, valiant because he suffered for sixty years with epilepsy, but never gave up working and fought against Hitler, with adoration. His daughter Frida Kahlo."

ing for all my problems."[4] She also recalled how, when she caught polio at the age of six, her father took particular care of her during her nine-month convalescence. Her right leg grew very thin, and her right foot was stunted in its growth. Although her father made sure that she regularly practised the physiotherapy exercises designed to build up her wasted muscles, her leg and foot remained deformed. An affliction which, as an adolescent, she sought to hide beneath trousers, and later behind long Mexican skirts. Having been cruelly nicknamed "peg-leg Frida" in her childhood – something which hurt her deeply, she attracted admiring attention in later life with her exotic attire. She often accompanied her father, an enthusiastic amateur artist, on his painting excursions into the local countryside. He also taught her how to use a camera and how to develop, retouch and colour photographs – experiences which were all very useful for her later painting. Her love and admiration for Guillermo Kahlo, whom

she described as "very interesting, very elegant in his movements, in his walk", as "quiet, industrious, brave", is clearly expressed in the *Portrait of My Father* of 1951 (ill. p. 10). He is shown with the tool of his trade, a large-format plate-back camera. The banderole across the bottom of the picture, a typical feature of 19th-century Mexican portrait painting, bears the inscription: "I painted my father Wilhelm Kahlo, of Hungarian-German origin, artist-photographer by profession, in character generous, intelligent and fine, valiant because he suffered for sixty years with epilepsy, but never gave up working and fought against Hitler, with adoration. His daughter Frida Kahlo."

Having finished her primary education at the Colegio Alemán, Mexico's German school, in 1922 Frida Kahlo became a student at the Escuela Nacional Preparatoria. The school had rigorous entrance examinations, served as a preparatory college for university, and rated as the best educational institute in Mexico. Frida Kahlo joined the first intake of thirty-five girls amongst a total of 2,000 pupils. She wanted to study natural sciences, in particular biology, zoology and anatomy, and hoped ultimately to become a doctor.

The school contained numerous cliques devoted to a variety of interests and activities. Frida Kahlo came into contact with several of them, and was herself a member of the "Cachuchas", a group named after the peaked caps which its members wore by way of a badge. They read a lot and supported the socialist-nationalist ideas of Minister of Public Education José Vasconcelos, which led them to argue for reforms to their own school. Their ranks numbered several later leaders of the Mexican Left; six of them are captured in *If Adelita...* or *The Peaked Caps* (ill. p. 12 below). The work consists of a collage-

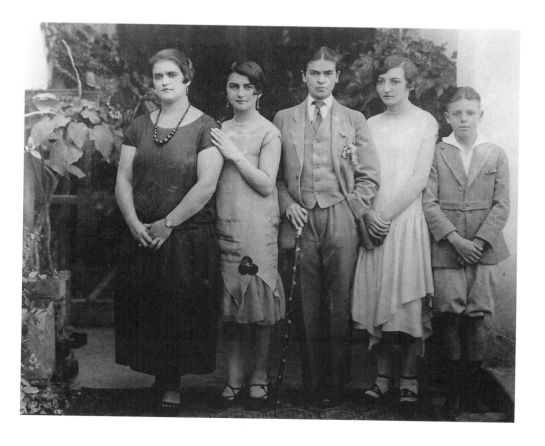

Frida Kahlo, wearing a man's suit, with members of her family, photographed on 7 February 1926 by Guillermo Kahlo. From left to right: sisters Adriana and Cristina, Frida Kahlo, and cousins Carmen Romero and Carlos Veraza.

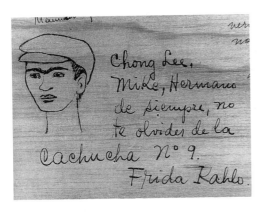

Chong Lee, Mike, older brother, don't forget Cachucha No. 9, around 1948–50
This wooden board carries inscriptions from old school friends congratulating the poet Miguel N. Lira on a success. Frida Kahlo added a portrait of herself wearing a *cachucha* peaked cap.

OPPOSITE PAGE:
Portrait of Miguel N. Lira, 1927
The artist herself was unhappy with this portrait of Miguel N. Lira. She shows her school comrade surrounded by various symbols of literature and poetry. The figure of the angel, to be understood as the Archangel Michael, points to his forename, Miguel, while the lyre behind represents his surname.

If Adelita... or *The Peaked Caps,*
before 1927
Frida was a member of the "Cachuchas", a group named after their peaked caps. They supported socialist-nationalist ideas and devoted themselves intensively to literature. The work consists of a collage-like compilation of elements symbolizing the interests of the group members gathered around the table.

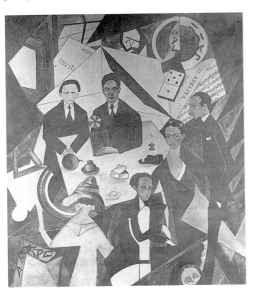

like compilation of elements representing the interests of the people gathered around the table in symbolic form – a domino, a jazz record, an envelope, the text of the folksong "La Adelita". The artist places herself in their midst, her pose and appearance very similar to her first *Self-portrait in a Velvet Dress* of 1926 (ill. p. 6). Below her appears a corner of the *Portrait of Ruth Quintanilla* which she painted in 1927, shortly before this work. The figure in profile is that of author Octavio Bustamante, whose book "Invitación al dancing" appears above left. To the left sits the musician and composer Angel Salas, whose activities are symbolized in the sheet of music above right. Next to him – in rear view – is the figure of Carmen Jaime, the only other female member of the group. On the far side of the table, the figure on the extreme left is that of Alejandro Gómez Arias, law student, journalist, and Kahlo's boyfriend. He went on to found a radio broadcasting station at Mexico University, which earned considerable admiration for its critical reporting, and became a respected intellectual. Lying on the table in front of his hands is a bomb, probably a reference to one of the many practical jokes which the "Cachuchas" played on their teachers. Next to him is the writer Miguel N. Lira, whom Frida Kahlo used to call Chong Lee owing to his love of Chinese poetry. On a wooden board from the late 1940s, carrying inscriptions from various friends congratulating the poet on a recent success, Frida Kahlo is also immortalized. Beside a small self-portrait of herself wearing the *cachucha* peaked cap, she wrote: "*Chong Lee, Mike, older brother, don't forget Cachucha No. 9*" (ill. p. 12 above).

In the *Portrait of Miguel N. Lira* of 1927 (ill. p. 13), Lira appears holding a windmill as in the earlier group picture. He is surrounded by symbols, some of which play upon his name: the figure of the angel thus establishes a connection between his forename, Miguel, and the Archangel Michael, while the lyre behind represents his surname. Kahlo discussed the picture in letters to Alejandro Gómez Arias: "I am painting a portrait of Lira, totally ugly. He wanted it with a background in the style of Gómez de la Sernas. [...] It's so bad that I simply don't know how he can tell me he likes it. Totally horrible....the background is artificial and he looks like a cardboard cut-out, only one detail seems good to me (one angel in the background). Oh well, you'll see it soon..."[5]

The work arose at the same time as other portraits of schoolmates and friends; some of these were destroyed by the artist herself, while others have simply gone missing. They represent her first attempts at painting. Up until 1925, her only artistic encouragement had come from Fernando Fernández, a friend of her father's who taught her drawing. Fernández, a respected commercial printmaker who had his studio very close to Kahlo's school, employed her as a paid apprentice as a means of helping her financially. He set her to copy prints by the Swedish Impressionist Anders Zorn, and was very surprised by her talent. Despite her interest in art, however, Kahlo herself stated that, prior to September 1925, she had never thought of pursuing a career as an artist. But her plans were soon to change.

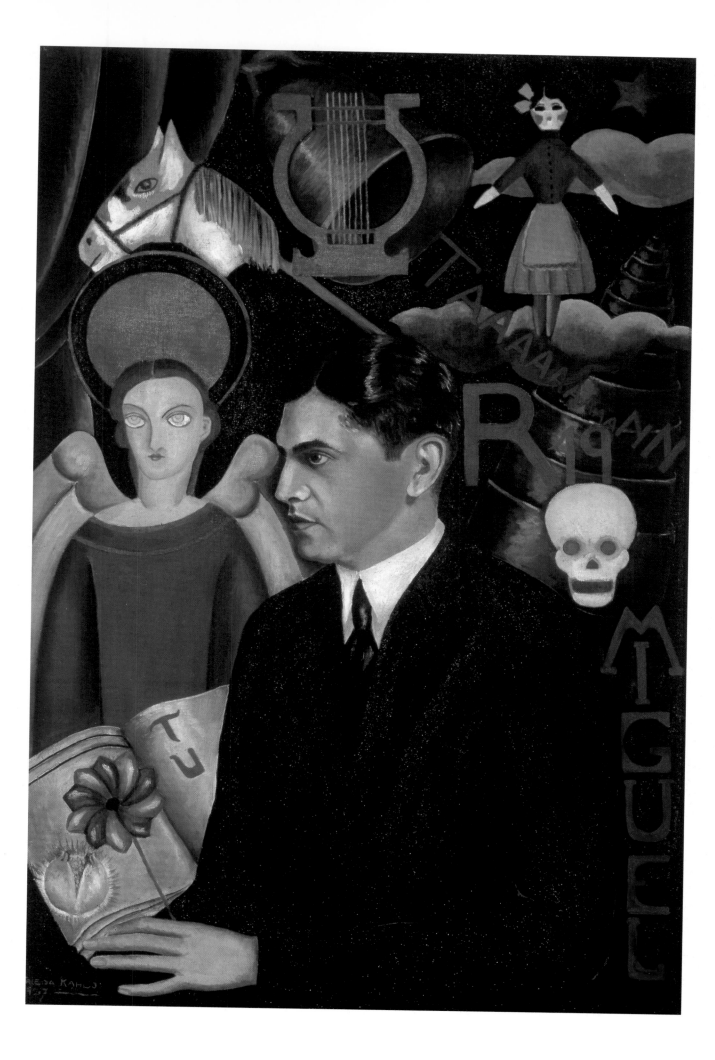

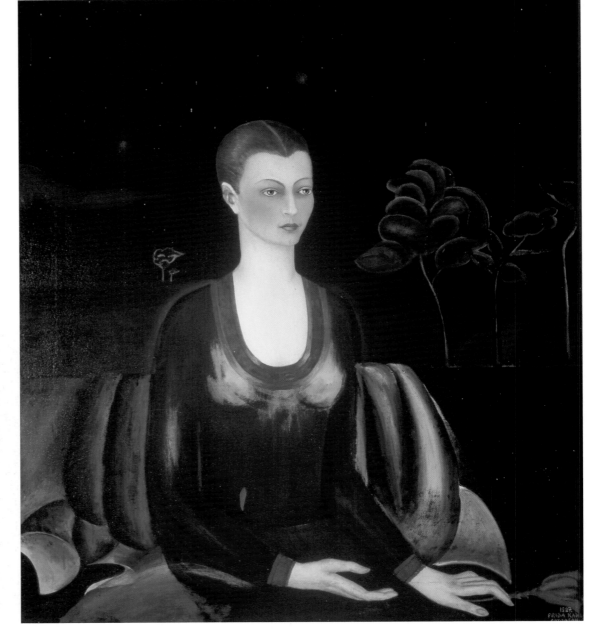

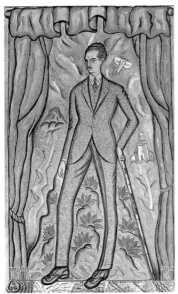

Adolfo Best Maugard
Self-portrait, 1923
In 1923 Adolfo Best Maugard wrote a treatise on the tradition, revival and development of Mexican art. The book made a profound impact on the painting of the young Frida Kahlo, and she employed some of its motifs in her own self-portrait of 1929 (ill. p. 28 above right).

Portrait of Alicia Galant, 1927
Like others of Frida Kahlo's early portraits, this picture of her friend Alicia Galant looks back to 19th-century Mexican portrait painting with its European influences. The gloomy Art Nouveau background differs greatly from the backgrounds of later portraits, which reveal a clear trend towards "Mexicanismo", Mexican national consciousness.

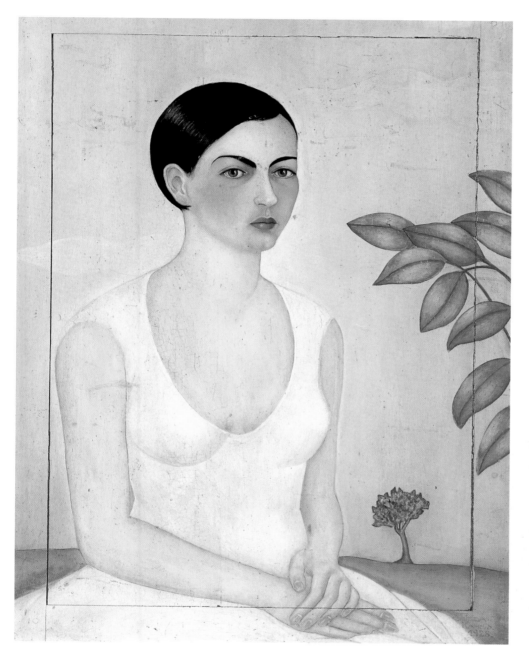

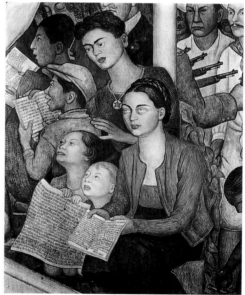

Portrait of My Sister Cristina, 1928
The pictures from the years 1928 and 1929, like this portrait of her sister, already reveal both the stylistic and thematic influence of the famous Mexican artist, Diego Rivera. Hard and somewhat rigid contours now characterize the composition. A small, stylized tree in the background contrasts with a large branch in the foreground to create the only suggestion of spatial depth. Cristina (1908–1964) was Frida Kahlo's younger sister.

Diego Rivera
The World of Today and Tomorrow (detail), 1929–1945
Diego Rivera's mural includes the figures of Frida Kahlo, her sister Cristina, and Cristina's children Isolda and Antonia. Cristina Kahlo also modelled for other of Rivera's works. This close contact between Frida Kahlo's husband and sister eventually developed, in 1934, into an affair.

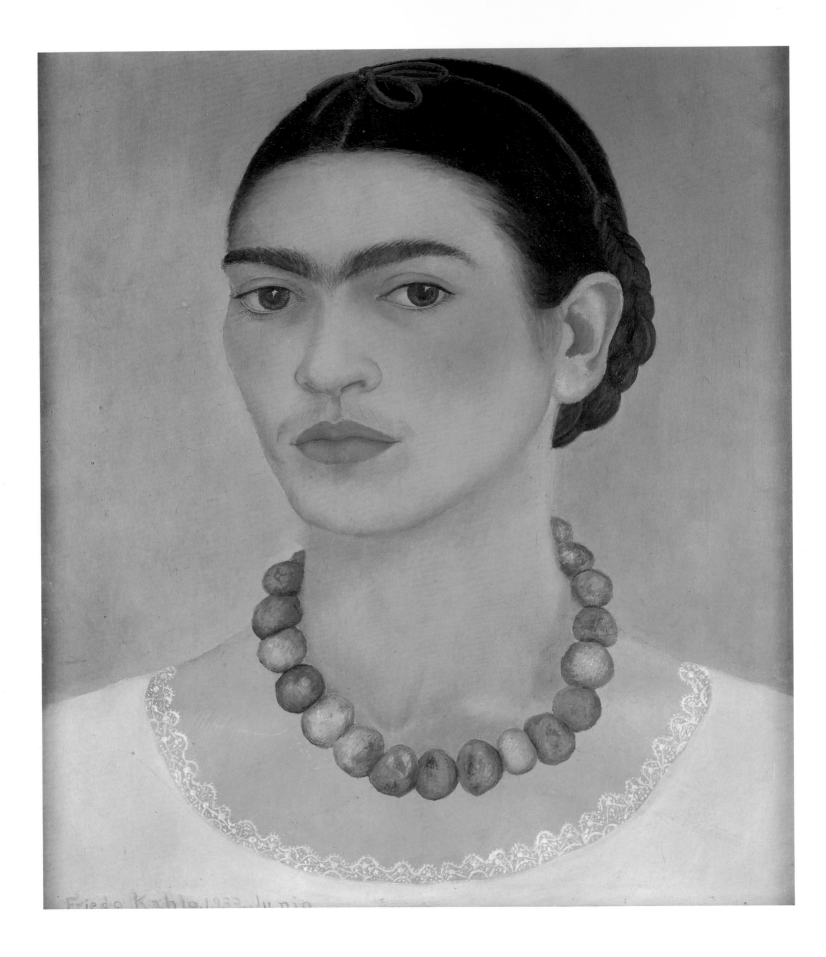

The delicate dove and the fat frog

On 17 September 1925, on their way home from school, Frida Kahlo and her boyfriend Alejandro Gómez Arias got onto the bus for Coyoacán. Shortly afterwards, there was a terrible accident: their bus collided with a tram, and several people were killed on the spot. Frida Kahlo suffered multiple injuries, leading the doctors to doubt whether she would survive. One year later, in the small pencil sketch *Accident* (p. 18 above), she recorded the fateful event which was to change her life so greatly. In the manner of popular votive art – a genre so important for her later work –, she portrays the scene with no consideration for the rules of perspective. In the upper half of the picture she sketches the moment of collision between the tram and the bus, pointing to its consequences in the bodies of the injured lying on the ground. In the foreground, and much larger than the figures behind, lies Frida Kahlo's own bandaged body on a Red Cross stretcher. Hovering above her is her own face, looking down on the scene with an expression of concern. On the left we see the front of the Blue House in Coyoacán to which she had been returning after school. This drawing is Frida Kahlo's only visual testimony of the accident; never again was she to return to the subject in her work. With one exception. In the early 1940s she came across a *Retablo* (ill. p. 18 below) whose subject so closely resembled her own accident that only a little retouching was needed to transform it into a representation of her own accident. She simply added the writing on the bus and tram, gave the injured woman the close-knit eyebrows so characteristic of her own face, and composed the dedication at the bottom: "Mr. and Mrs. Guillermo Kahlo and Matilde C. de Kahlo give thanks to Our Lady of Sorrows for saving their daughter Frida from the accident which took place in 1925 on the corner of Cuahutemozin and Calzada de Tlalpan."

The accident left her confined to bed for three months. She spent one month in hospital. After initially seeming to make a full recovery, she began to suffer frequent pain in her spine and her right foot. She also felt permanently tired. Eventually, about a year later, she was readmitted to hospital. Her spine had not actually been X-rayed at the time of the original accident, and only now was it discovered that a number of her vertebrae were displaced. For the next nine months she had to wear a succession of plaster corsets. She poured

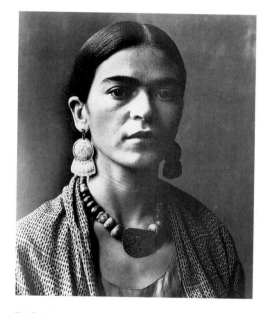

Frida Kahlo, photographed in 1931 by Imogen Cunningham (1883–1976). She is wearing one of her beloved pre-Columbian necklaces and colonial earrings.

Self-portrait with Necklace, 1933
While still in Detroit, Frida Kahlo slowly overcame her unhappiness following her miscarriage and took up the threads of her old life. This self-portrait shows her wearing a necklace of pre-Columbian jade beads. She appears fresh and attractive and expresses greater self-confidence than in the *Self-portraits* of 1929 and 1930. The picture was purchased in early 1938 by the American actor Edward G. Robinson.

17

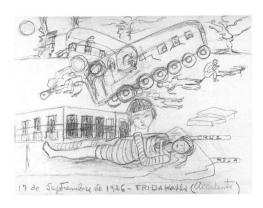

Accident, 1926
One year after the event, Frida Kahlo recorded the fateful accident which was to change her life so greatly. As a result of the serious injuries which she suffered to her spine and pelvis, she was subsequently unable to bear a child and was subject to lifelong pain in her back. In the style of popular ex-voto painting, she presents the scene with no consideration for the rules of perspective.

out her feelings during this period, in which she was severely restricted in her freedom of bodily movement and at times even had to remain immobile in bed, in countless letters to Alejandro Gómez Arias. It was during these months that she began to paint, as a means of escaping the boredom and pain. "I felt I still had enough energy to do something other than studying to become a doctor. Without giving it any particular thought, I started painting", she later told the art critic Antonio Rodríguez.

"For many years my father had kept a box of oil paints and some paintbrushes in an old jar and a palette in the corner of his photographic studio. He liked to paint and draw landscapes near the river in Coyoacán, and sometimes he copied chromolithographs. Ever since I was a little girl, as the saying goes, I'd had my eye on that box of paints. I couldn't explain why. Being confined to bed for so long, I finally took the opportunity to ask my father for it. Like a little boy whose toy is being taken away from him and given to a sick brother, he 'lent' it to me. My mother asked a carpenter to make me an easel, if that's what you can call the special apparatus which could be fixed onto my bed, because the plaster cast didn't allow me to sit up. And so I started on my first picture, the portrait of a friend."[6]

The bed was also given a canopy with a mirror covering its entire underside, so that Frida could see herself and be her own model. This saw the start of the self-portraits which dominate Frida Kahlo's oeuvre and which provide a virtually unbroken record of every stage of her artistic development. A genre of which she was later to say: "I paint myself because I am so often alone and because I am the subject I know best."[7]

Retablo, around 1943
Frida Kahlo found a votive picture whose subject so closely resembled her own accident that only a little retouching was needed to transform it into a representation of her own experience. She added the writing on the bus and tram, gave the unfortunate victim her characteristic close-knit eyebrows, and composed the thanksgiving inscription at the bottom.

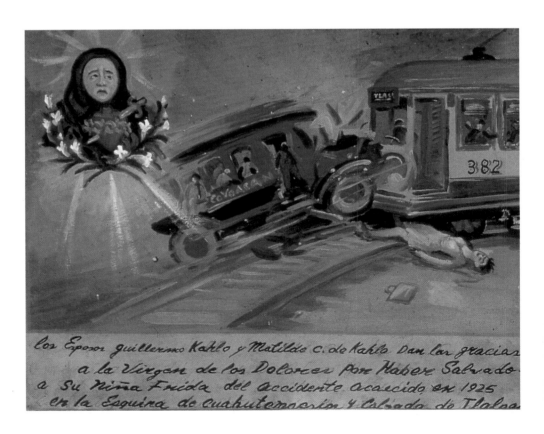

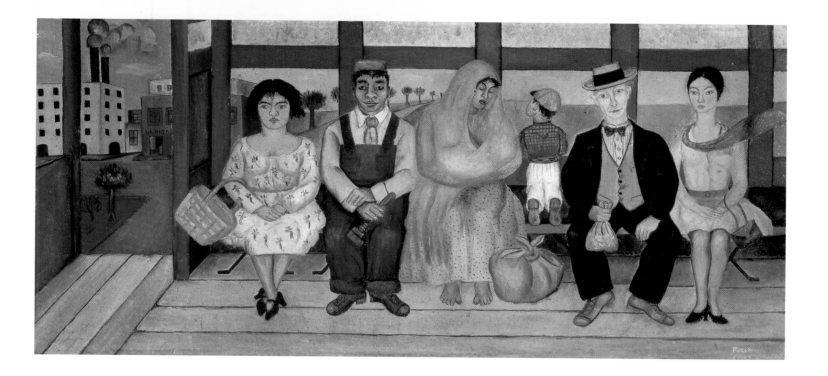

The Bus, 1929
Here, like Diego Rivera in his murals, the artist addresses a social subject. Archetypes of Mexican society sit next to each other inside the bus: a housewife, a worker, an indigenous Indian woman breastfeeding her baby, a small boy, a bourgeois and a young woman who looks like Frida Kahlo.

Her words contain the key to the most striking characteristic of her paintings. In the majority of her full-length self-portraits, the artist portrays herself against a backdrop of vast, bare landscapes or empty, cold rooms, reflecting her own loneliness (ills. p. 42/43). This same sense of solitude pervades her head and half-length portraits, too. Where she appears on the canvas in the company of her pets, she gives the impression of a child taking comfort from a teddy-bear or doll. Her head and half-length portraits are frequently accompanied by attributes with a symbolic meaning (ills. p. 28/29). Her full-length portraits, on the other hand, which are often presented in a scenic setting, are predominantly linked to real biographical events: the artist's relationship with her husband Diego Rivera, her physical condition – her ill health following the accident, her inability to carry a child through a full term of pregnancy – as well as her philosophy of nature and life and her view of the world. With her highly personal images, she broke the taboos of her day, in particular those surrounding the female body and female sexuality. Already in the 1950s Diego Rivera was acknowledging her as "the first woman in the history of art to treat, with absolute and uncompromising honesty, one might even say with impassive cruelty, those general and specific themes which exclusively affect women."[8] During her time confined to bed, Frida Kahlo had the opportunity to make an intensive study of her own mirror image. This self-analysis took place at a time when, having only recently escaped death, she was starting to discover and experience both her own self and the world about her at a new and more conscious level. "From that time, my obsession was to begin again, painting things just as I saw them with my own eyes and nothing more"[9], she told Rodríguez. The photographer Lola Alvarez Bravo observed that the artist had found

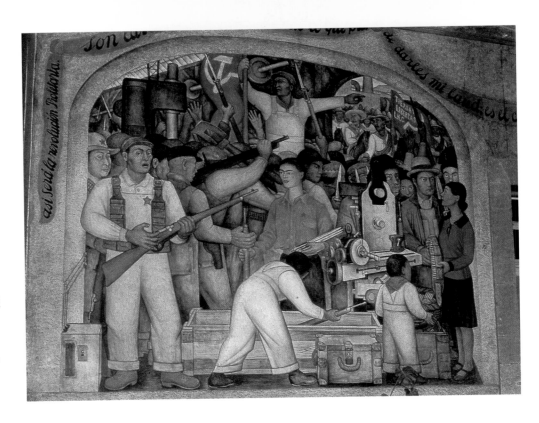

Diego Rivera
Ballad of the Revolution (detail), 1923–28
The mural shows friends of Frida Kahlo's and Rivera's from the circle around the Cuban Communist Julio Antonio Mella. Mella, at that time in exile in Mexico, appears on the right next to his lover, the photographer Tina Modotti. Both Modotti and Mella were in close contact with progressive men and women artists. Standing on the left is the artist and passionate Communist David Alfaro Siqueiros, one of Rivera's close friends. Frida Kahlo is shown as a member of the Mexican Communist Party (PCM), which she joined in 1928. Together with her party comrades, she supported the armed class struggle of the Mexican people.

new life through painting, and that the accident had been followed by a sort of rebirth, in which her love of nature, animals, colours and fruits, of anything beautiful and positive, had been renewed.[10]

Frida Kahlo's self-portraits helped her to shape an idea of her own person; by creating herself anew in art as in life, she could find her way to an identity. This may explain why her self-portraits differ in only relatively small respects. The artist looks out at the viewer with almost always the same mask-like face, in which feelings and moods can be read only with difficulty. Her eyes, framed by the heavy, dark eyebrows which met like the wings of a bird above her nose, are particularly impressive.

In order to express her ideas and feelings, Frida Kahlo developed a personal pictorial language employing its own vocabulary and syntax. She used symbols which, once decoded, offer insights into her oeuvre and the circumstances surrounding its creation. Her message is not hermetic: her works should be viewed as metaphorical summaries of concrete experiences. The rich imagery which fills Frida Kahlo's works is derived first and foremost from Mexican popular art and pre-Columbian culture. The artist also draws upon the stylistic vernacular of *retablos*, votive paintings of Christian saints and martyrs which have a permanent place in popular religious belief. She refers to traditions which, however surreal they may strike the European, continue to flourish in Mexican daily life even today. But although many of her works contain surreal and fantastical elements, they cannot be called Surrealist, for in none of them does she entirely free herself from reality. Her messages are never impenetrable or illogical. Fact and fiction fuse in her works, as in so many Mexican works of art, as two components of one and the same reality.

Frida Kahlo's first self-portrait, the *Self-portrait in a Velvet Dress* of 1926 (ill. p. 6), and her early portraits of friends and sisters are still oriented towards European-influenced Mexican portrait painting of the 19th century. Examples here include the *Portrait of Miguel N. Lira* (ill. p. 13), the *Portrait of Alicia Galant* (ill. p. 14) and the *Portrait of My Sister Cristina* (ill. p. 15). These differ greatly from the artist's later portraits, which reveal a clear trend towards Mexicanism, Mexican national consciousness. This sense of national identity was shared after the Revolution by the whole country.

The election of Alvaro Obregóns as president (1920) and the foundation of a Ministry of Public Education under José Vasconcelos not only helped combat illiteracy, but also launched a comprehensive cultural reform movement whose aim was to achieve equal status and cultural integration for the Indian population and to reestablish an own Mexican culture. The attitudes which had led Indian culture to be repressed since the Spanish conquest, and encouraged a European-influenced academic art from the 19th century onwards, now found themselves challenged. Artists who had felt the previous conventional imitation of European models to be degrading called for an independent Mexican art free of all academic posturing. They argued for a return to the nation's roots and the reinstatement of Mexican folk art.

Frida Kahlo joined up with this circle of artists and intellectuals in 1928. Her health had recovered to the extent that, by the end of 1927, she was once more living a largely "normal" life. She resumed contact with her old school friends. Many of them had since left the Preparatoria and were now politically active at the university. At the start of 1928, Germán de Campo, a friend from her schooldays, introduced her to a group of young people centred around the Cuban

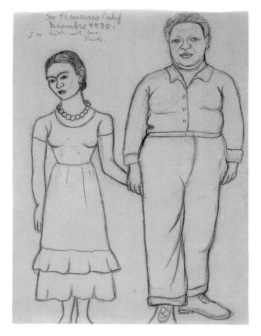

Frieda Kahlo and Diego Rivera
or ***Diego and Frieda,*** 1930
This drawing is a sketch for the oil painting of the same name (ill. p. 23), which she completed six months later. Up until the early thirties, Frida frequently used the German spelling of her name, "Frieda".

Frida Kahlo and Diego Rivera at a Labour Day demonstration on 1 May 1929 in Mexico.

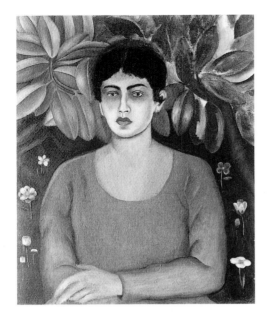

Portrait of Lupe Marín, 1929
Rivera's previous wife, Lupe Marín (married to Rivera from 1922 to 1927), took Frida Kahlo under her wing. They went out shopping together for pots and pans, and Lupe showed her how to make Rivera's favourite dishes. By way of thanks for her cookery lessons, Frida Kahlo painted Lupe's portrait.

Frieda and Diego Rivera
or *Frieda Kahlo and Diego Rivera,* 1931
This double portrait may have been based on a wedding photograph. The difference in height between the couple appears exaggerated, but was in fact the case. Frida Kahlo's dainty feet barely touch the ground. She appears instead to float beside her corpulent husband, whose big feet are planted firmly on the ground. Rivera is identified as an artist by his palette and brushes – she presents herself as the wife of the brilliant painter. She gave the picture to art collector Albert Bender in gratitude for the USA entry visa which he organized on Rivera's behalf. Rivera had initially been refused a visa due to his Communist sympathies.

Communist Julio Antonio Mella, who was currently in exile in Mexico. Mella was the lover of the photographer Tina Modotti, herself in close contact with progressive men and women artists.

It was through Modotti that Frida Kahlo met Diego Rivera. Kahlo had already seen Rivero once before, at the Escuela Nacional Preparatoria, where he had painted his first mural in the school's Simón Bolívar amphitheatre in 1922. She now went to see the artist – who had since become famous – in the Ministry of Public Education, where he had been working on a new mural since 1923. She greatly admired both the man and his painting, and wanted to ask him what he thought of her own efforts and whether he considered her talented. Rivera was immediately impressed by the works she showed him: "The canvases revealed an unusual energy of expression, precise delineation of character, and true severity. [...] They had a fundamental plastic honesty, and an artistic personality of their own. They communicated a vital sensuality, complemented by a merciless yet sensitive power of observation. It was obvious to me that this girl was an authentic artist."[11]

Diego Rivera strengthened her resolve to pursue a career as an artist, and from now on was a frequent guest at the Kahlo home. He incorporated a portrait of Frida Kahlo into his *Ballad of the Revolution* mural in the Ministry of Public Education. She appears in the panel *Frida Kahlo Distributes the Weapons* (ill. p. 20), flanked by Tina Modotti, Julio Antonio Mella and David Alfaro Siqueiros. Dressed in a black skirt and a red shirt, and wearing a red star on her breast, she is shown as a member of the Mexican Communist Party (PCM), which she in fact joined in 1928. Together with her party comrades, she supported the armed class struggle of the Mexican people.

She herself portrays a very different Frida Kahlo in her second self-portrait, *Self-portrait "Time flies"* (ill. p. 28 above right) of 1929. A comparison between this and her *Self-portrait in a Velvet Dress* of September 1926 (ill. p. 6), a gift for her then boyfriend Alejandro Gómez Arias, makes clear the change in her style. The earlier work reflects her interest in the painting of the Italian Renaissance; she is portrayed in an aristocratic, somewhat melancholic pose, her neck manneristically elongated in the style of Amedeo Modigliani. In the second self-portrait, by contrast, she offers a frontal view of her fresh, red-cheeked face, gazing confidently out at the viewer and wearing a positive, determined expression. The elegant velvet dress with its exquisite brocade has given way to a simple cotton blouse – a popular item of clothing which can still be purchased in markets throughout Mexico today. The gloomy Art Nouveau background of the earlier portrait, found also in the *Portrait of Alicia Galant* (ill. p. 14), is here flooded with light: the curtains have been tied back with thick red cords, and in the sky above the balcony railings we see a propeller plane looping the loop. The ornate stand behind Frida Kahlo's shoulder on the right carries an ordinary metal alarm clock, and not the precious *objet d'art* we might expect. In her inclusion of the aeroplane and the clock, she illustrates the proverbial expression: "Time flies".

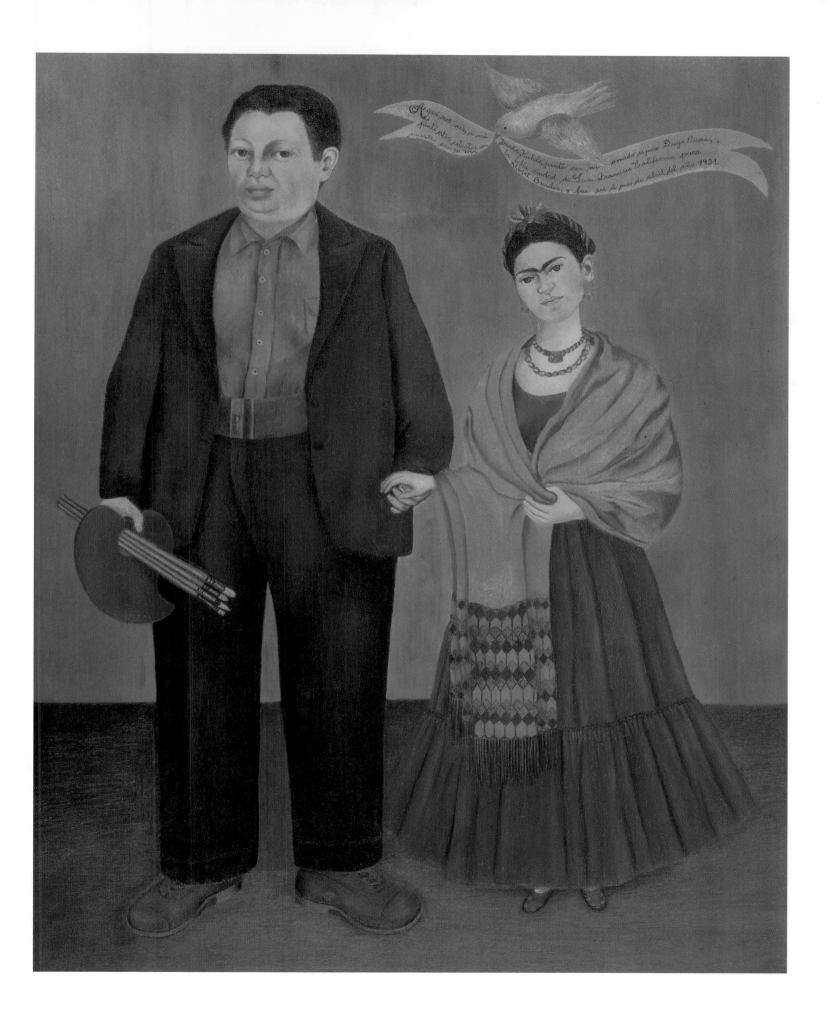

ABOVE AND BELOW:
José Guadalupe Posada (1851–1913)
Untitled illustrations
(cf. ill. p. 56 above)

On 21 August 1929 Frida Kahlo married Diego Rivera, twenty-one years her senior. His ideological influence upon her is reflected both in the picture of 1929 described above and in Frida Kahlo's involvement in the circle of Mexican artists and intellectuals calling for an independent Mexican art. "Mexicanism" was to find its expression first and foremost in the mural paintings which were sponsored by the state as a means of educating the country's large illiterate population in the history of their nation. José Clemente Orozco, Diego Rivera and David Alfaro Siqueiros won particular acclaim as mural artists. "Nationalist ideas" were not limited to monumental painting, however, but were also the subject of smaller canvases by leading artists such as Gerardo Murillo (known as Dr. Atl), Adolfo Best Maugard and Roberto Montenegro. Elements of folk art were to be reinstated in "fine" art, whereby works of popular art were not – as nevertheless still happened – simply to be removed from their practical context, brought into the cities and exhibited as works of art, but were to be integrated directly into the new works created by modern artists. In 1923 Adolfo Best Maugard wrote a book on the tradition, revival and development of Mexican art. It opened with a theoretical introduction to the social function of art and the significance of *arte popular,* and was followed by an essay with examples of elements and forms from Mexican popular art. His theories are illustrated in his own *Self-portrait,* painted that same year (ill. p. 14 left). Here he invokes elements discussed in his book – the stylized, non-perspective method of representation, for example – to indicate the Indian sources of Mexican popular art. He exposes the colonial sources of (often anonymous) Mexican 19th-century portrait painting in a similar manner; in depicting curtains tied back by cords, for example, he cites a typical feature of 19th-century portraits which can

Frida Kahlo's bed
The skeleton attached to the underside of the canopy over her bed is alleged to have been a light-hearted reminder of her own mortality. The skeleton motif appears often in the work of the Mexican artist. In Mexico, death is understood as a process, as a path or transition to a life of a different kind. The Day of the Dead on 2 November is thus not a day of mourning, but a festival.

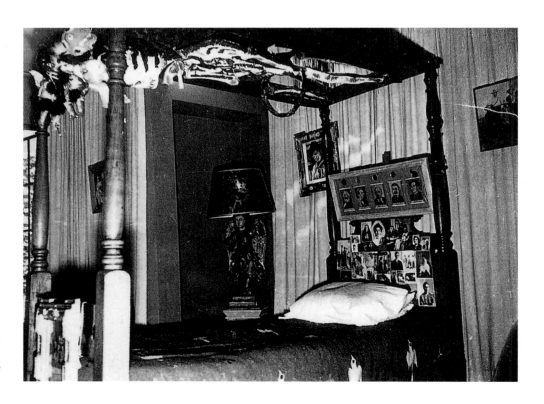

Portrait of Luther Burbank, 1931
Luther Burbank was a horticulturalist famed
for his unusual vegetable and fruit hybrids.
Frida Kahlo shows Burbank himself as a hy-
brid – half man, half tree. In this picture we
see her work turning away for the first time
from the straightforward representation of ex-
ternal reality. In the skeleton at the bottom
she treats her favourite subject – the birth of
new life through death.

be traced back to works from the colonial era and which had also
been incorporated into popular art. The hilly background terrain, the
castle with the Mexican flag flying from its turret, the sun, the aero-
plane and even the decoration of the stage-like flooring in the fore-
ground are similarly all employed in accordance with the ideas set
forth in his book. It is highly probable that Frida Kahlo was familiar
both with Best Maugard's book and his self-portrait when she joined
the artists' circle. Her *Self-portrait "Time flies"* of 1929 employs a cor-
responding symbolism. In such details as her simple clothing, colo-
nial earrings and a pre-colonial jade necklace, Frida Kahlo points to
pre-Columbian and colonial cultural influences. She thereby acknow-
ledges the roots of Mexican culture and declares herself a mestiza, a

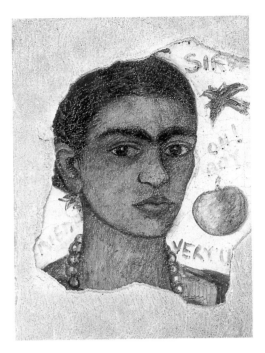

Self-portrait "very ugly", 1933
This self-portrait was painted as a fresco. Its original inscription is no longer complete since the fresco is badly damaged at its edges and corners.

"true" Mexican woman whose veins run with a mixture of Indian and Spanish blood. The picture becomes the expression of her national consciousness, dominated by the colours green, white and red of the Mexican flag. Differences in technique aside, motifs such as the small propeller plane and the curtains symmetrically framing the scene (which serve as backdrop in other Kahlo portraits, too), further suggest that Frida Kahlo may have modelled her *Self-portrait "Time flies"* on Best Maugard's earlier self-portrait.

With reference to the "Mexicanism" in Frida Kahlo's art, Diego Rivera remarked that: "Different critics from various countries have described Frida Kahlo's painting as the most forceful and the most Mexican of the present day. I entirely agree with them. [...] Of all the well-known painters on the art market at the spearhead of national art, Frida Kahlo is the only one who is drawing, closely and without hypocrisy or aesthetic prejudice, but rather, one might say, for the sake of the thing itself, upon this pure product of popular art [votive painting]."[12]

From popular art Frida Kahlo borrowed her palette and certain of her motifs, such as the skeleton-like "Judas figures" which accompany her in some of her self-portraits. She took elements from the votive paintings of anonymous amateur artists, and at the same time drew inspiration from pre-Columbian culture and Mexican 19th-century portraiture. The objects of folk art which Frida Kahlo incorporated into her work were simultaneously gaining access to the homes of Mexican intellectuals as decorative handicrafts. The Kahlo-Rivera household, too, had its own collection of rustic furniture, lacquer-painted objects, masks, papier-mâché Judas figures and votive panels.

In her self-portraits Frida Kahlo usually shows herself wearing simple, unsophisticated clothing or in Indian costume, whereby she expressed her identification with the indigenous population and thus her own national identity. "In another period I dressed like a boy with shaved hair, pants, boots and a leather jacket. But when I went to see Diego, I put on a Tehuana costume."[13] The artist did indeed wear men's clothing for a while, establishing her image as an unusual, independent woman. She subsequently reinforced this image by donning the richly-decorative dress of the women from the isthmus of Tehuantepec. This became her preferred clothing after her marriage to Rivera, not least because the floor-length skirt enabled her to hide her physical deformity, her somewhat shorter, thin right leg. The Tehuantepec region in southwest Mexico is one in which matriarchal traditions survive even today, and its economic structure reflects the dominant role of women. This fact seems to have had particular appeal for many intellectuals, and in the twenties and thirties Tehuana costume was adopted by many educated Mexican city women. It perfectly matched the growing spirit of nationalism and the revived interest in Indian culture. "The classic Mexican dress has been created by people for people", according to Diego Rivera. "The Mexican women who do not wear it do not belong to the people, but

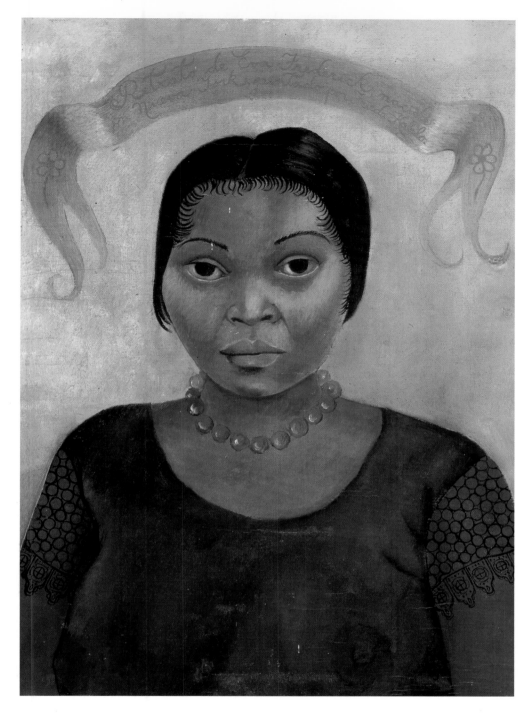

Portrait of Eva Frederick, 1931
During her stay in San Francisco from November 1930 to June 1931, Frida Kahlo painted a number of portraits of friends and acquaintances. Although we know nothing more than Eva Frederick's name today, it is not difficult to deduce that Frida Kahlo must have felt great sympathy for her sincere and intelligent sitter.

are mentally and emotionally dependent on a foreign class to which they wish to belong, i.e. the great American and French bureaucracy."[14]

In Frida Kahlo, who wore Mexican costumes, Diego Rivera saw "the personification of all national glory."[15] It was with similar ideological ends in mind that the artist designed the backgrounds to her self-portraits and selected the attributes which accompanied her. Thus she shares the limelight with the flora and fauna of Mexico, with cacti, plants of the primeval forest, volcanic rock, parrots, deer, monkeys and Itzcuintli dogs – animals which she kept as pets and which appear in her pictures as the companions of her solitude.

ILLUSTRATIONS PAGE 28/29:
Over half of Frida Kahlo's pictures are self-portraits. Particularly during her separation and divorce from her husband around 1939, she painted almost exclusively only herself. In all her portraits she seeks to express her current mood.

"I paint myself because I am so often alone and because I am the subject I know best."
FRIDA KAHLO

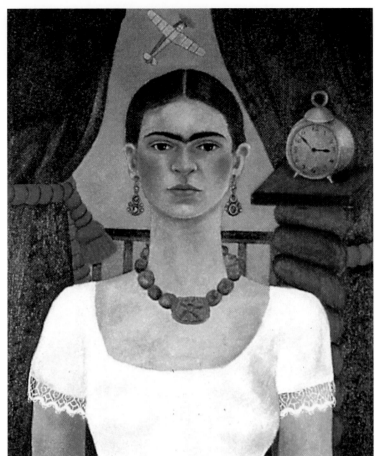

Self-portrait, around 1923

Self-portrait "Time flies", 1929

Self-portrait with Monkey, 1940

Self-portrait with Small Monkey, 1945

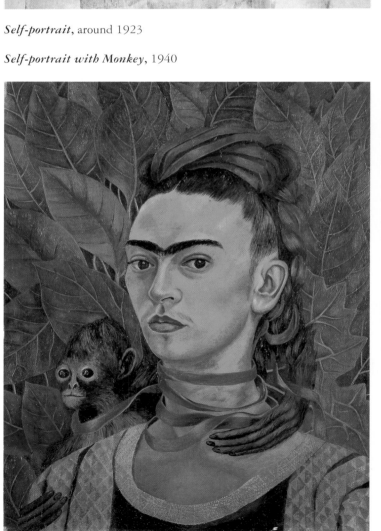

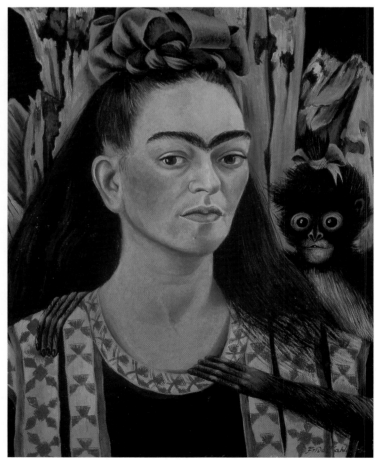

Self-portrait, 1930

Self-portrait with Necklace of Thorns, 1940

Self-portrait with Hair Loose, 1947

Self-portrait, 1948

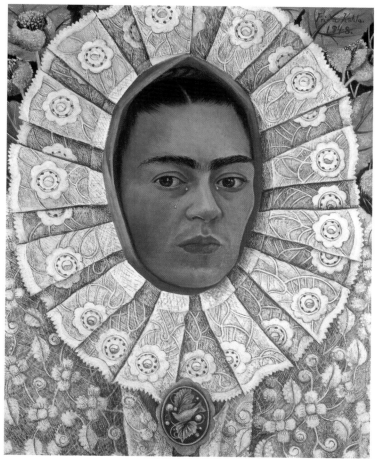

A Mexican artist in "Gringolandia"

In November 1930 Frida Kahlo and Diego Rivera moved to the USA for four years. San Francisco was their first stop. Diego Rivera had been commissioned to paint murals for the San Francisco Stock Exchange and the California School of Fine Arts, today the San Francisco Art Institute.

His decision to live and work in the United States for such a lengthy period was based on both artistic and political considerations. The North Americans were very interested in the cultural development – the so-called Mexican Renaissance – of their southern neighbours. At the same time, the USA represented a powerful magnet for Mexican artists, a number of whom moved to America to profit from its more strongly developed art market.

Under the presidency of Plutarco Elías Calles, head of state from 1924 to 1928, the situation of mural painters in Mexico had steadily worsened. His new cultural and educational policies no longer included unlimited funding for mural projects; painting contracts had been terminated with the dismissal of Minister of Public Education Vasconcelos in 1924. The number of commissions fell, and some frescos were even destroyed, among them *The Creation* which Rivera had painted in the Simón Bolívar amphitheatre in the Escuela Nacional Preparatoria.

The years between 1928 and 1934, spent under a successor government still controlled by Calles, saw repressive moves against political opponents. The PCM was banned and numerous Communists thrown into gaol. The situation precipitated a "Mexican invasion" of the United States. The decision by the recently-wed Kahlo-Riveras to go abroad must also be seen in this light.

In San Francisco Frida Kahlo met artists, clients and patrons, amongst them Albert Bender, an insurance agent and art collector who had already purchased a number of works from Diego Rivera during earlier trips to Mexico. It was Bender, through his extensive network of contacts, who had succeeded in procuring for Rivera the United States entry visa which had initially been denied him on the basis of his Communist sympathies, despite the fact that the artist had left the Communist Party in 1929 because of its trend towards Stalinism.

In gratitude, Frida Kahlo painted for Bender the first of a series

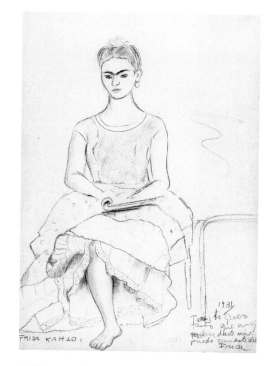

Self-portrait, sitting, 1931
During her stay in the USA, Frida Kahlo suffered considerable discomfort from an ulcer on her foot. The polio which she had contracted as a child left one of her legs stunted. It was a source of pain throughout her life, and after several operations it was eventually amputated shortly before her death.

Self-portrait "The Frame", around 1938
In 1939, the "Mexique" exhibition organized by André Breton took place in Paris, featuring examples of Mexican painting, sculpture, photography and popular art. This self-portrait was amongst the exhibits, and was the first work by a 20th-century Mexican artist to be purchased by the Louvre. Rivera was very proud of this honour and often boasted about his wife's Paris triumph. The portrait and the blue ground are painted on an aluminium sheet. The decorative border of flowers and the two birds are painted on glass placed in front of the portrait.

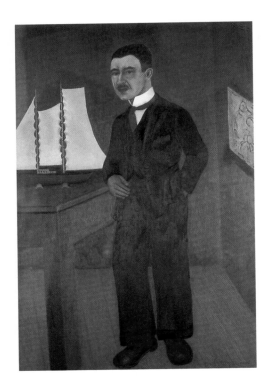

Portrait of Dr. Leo Eloesser, 1931
From November 1930 to June 1931 the Riveras lived in San Francisco, where Diego was to execute a mural commission. During this period Frida Kahlo had to go to hospital with problems with her right foot. There she met Dr. Leo Eloesser, who had been a friend of Rivera's since 1926. He was to become her most trusted medical advisor for the rest of her life. This portrait is an expression of her gratitude to the doctor for his friendship.

of double portraits of herself and her husband, *Frieda Kahlo and Diego Rivera* (ill. p. 23). The composition is kept deliberately traditional, oriented in form and style to the Mexican portraits of the 18th and 19th century. Possibly based on their actual wedding photograph, the difference in height between the couple appears exaggerated, but was in fact the case. The artist's dainty feet hardly touch the ground. She appears instead to float beside her corpulent husband, whose big feet are planted firmly on the ground. Identified as an artist by his palette and brushes, Rivera looks confidently out at the viewer, while Frida Kahlo, her head inclined almost shyly to one side and her hand placed timidly in Rivera's, presents herself as the wife of the brilliant painter. Although she spent most of her six-month stay in San Francisco at her easel, Frida Kahlo clearly did not yet have the courage to portray her own self as an artist.

After Rivera had finished his work in San Francisco in June 1931, the couple made just a brief visit to Mexico before moving on to New York, where Rivera had been invited to attend a comprehensive retrospective of his works. In April 1932 the couple then went to Detroit for almost a year. Rivera was to paint a fresco on the subject of modern industry for the Detroit Institute of Arts.

In 1930 Frida Kahlo had had to undergo an abortion for medical reasons. In Detroit she became pregnant a second time, even though she had been told after her bus accident that she would probably never be able to carry a child to term; her pelvis, which had been fractured in three places, would no longer allow a correct foetal position or a normal birth. In San Francisco in December 1930 she had met Dr. Leo Eloesser, a well-known surgeon with whom she became good friends; in 1931 she painted him in the *Portrait of Dr. Leo Eloesser* (ill. p. 32). At the start of her second pregnancy, on his advice, she consulted a doctor at the Henry Ford Hospital in Detroit. "He told me (...) that his opinion is that it would be much better if instead of making me abort with an operation I should keep the baby and that in spite of the bad condition of my organism, bearing in mind the little fracture of the pelvis, spine, etc., etc., I could have a child with a Caesarean operation without great difficulties", she wrote (in English) to Dr. Eloesser, whom she trusted implicitly on the subject of her health and whose advice she frequently sought. "Do you think that it would be more dangerous to abort than to have a child?"[16]

In the same letter she also discussed other complicating factors which made her feel that a pregnancy was perhaps not the best idea. She also mentioned that Rivera was not interested in having children. Before the doctor had had a chance to reply, however, she seems to have made up her mind to go through with the pregnancy. As she later told him: "At that time I was enthusiastic about having the child after having thought of all the difficulties that it would cause me."[17]

Her disappointment must have been all the greater, therefore, when on 4 July that year she had a miscarriage and lost the baby she so desired. The artist began recording the traumatic experience of

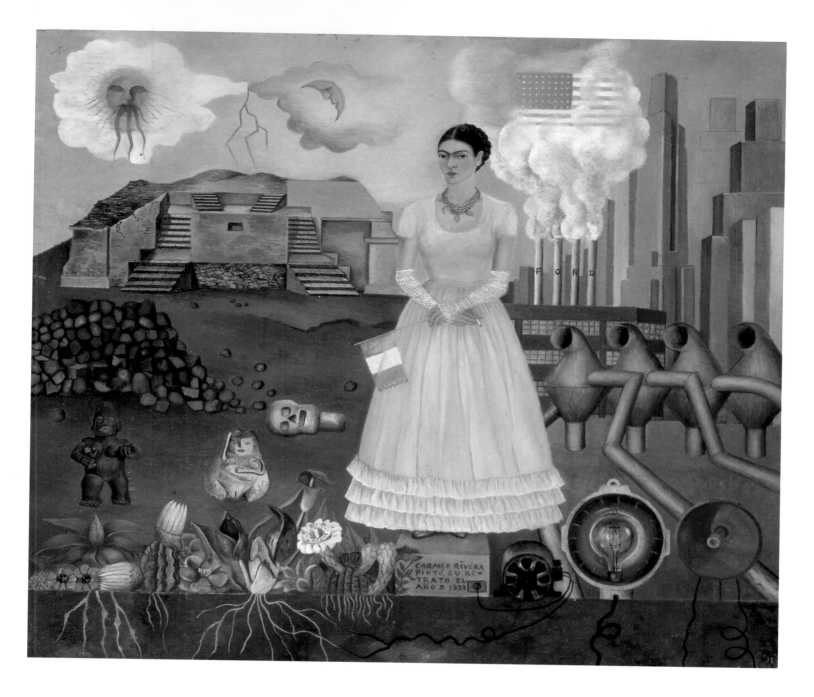

her miscarriage in a pencil drawing even during the thirteen days she spent recovering in hospital. The sketch later became the model for the oil painting *Henry Ford Hospital* (ill. p. 37). The painting shows the artist lying naked in a hospital bed which is far too big in relation to her body. The white sheet beneath her lower abdomen is soaked in blood. Over her belly, still slightly swollen from the pregnancy, she holds three red artery-like ribbons in her left hand, with six objects tied to their ends – symbols of her sexuality and her failed pregnancy. The ribbon branching out above the pool of blood surrounding her pelvis becomes an umbilical cord, and leads to an outsize male foetus in embryonic position. It is the child lost in the miscarriage, the little "Dieguito" whom she had hoped to carry a full nine months.

A snail floats over the head of the bed on the right. According to Frida Kahlo herself, it is a symbol of the slow course of the miscar-

Self-portrait on the Borderline between Mexico and the United States, 1932
In this picture Frida Kahlo makes clear her ambivalent feelings towards "Gringolandia". In an elegant pink dress and with a Mexican flag in her hand, she stands like a statue on a pedestal between two different worlds – on the one side, the ancient Mexican landscape, governed by the forces of nature and the natural life cycle, and on the other the dead, technology-dominated landscape of North America.

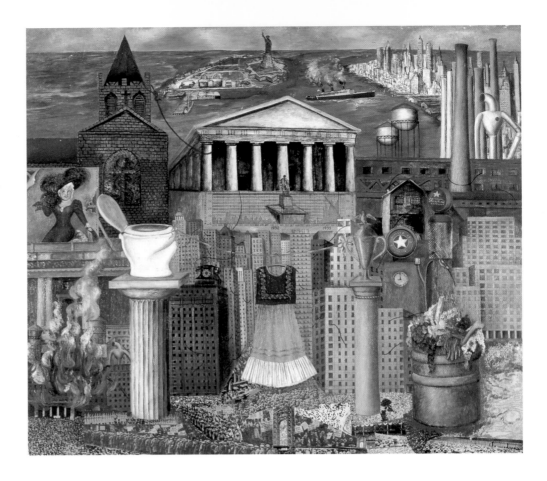

My Dress Hangs There or *New York,* 1933
While Frida Kahlo had grown weary of America and the Americans, Rivera remained fascinated by the country and did not want to leave. This work, the only collage in the artist's oeuvre, represents an ironic portrait of American capitalism. Filled with symbols of modern American industrial society, it points to social decay and the destruction of fundamental human values. Frida Kahlo thereby takes an opposite view to her husband, who was currently expressing his approval of industrial progress in a mural in the Rockefeller Center.

Exquisite Corpse (together with Lucienne Bloch), around 1932
Lucienne Bloch met Frida Kahlo and Diego Rivera at a dinner in Manhattan in 1931. Lucienne worked as Rivera's assistant and became good friends with Frida Kahlo. This Exquisite Corpse (*Cadavre exquis,* as the Surrealists originally named such drawings) is the product of an entertaining game: each person draws one third of a figure, then folds the paper over and passes it on to the next person.

riage. The snail also appears in other of her works (ills. p. 67 and p. 74) as a symbol of vitality and sexuality. Its protective housing led Indian cultures to see the snail as a symbol of conception, pregnancy and birth. In its emergence and withdrawal into its shell, it is linked to the waxing and waning of the moon, which in turn stands for the female cycle and thus female sexuality *per se.*

The salmon-pink anatomical model of the lower part of a body over the foot of the bed, like the bone model below right, indicates the cause of the miscarriage, namely the damaged backbone and pelvis which made it impossible for Frida Kahlo to have a child.

The piece of machinery below left may also be understood in this context. It probably represents part of a steam sterilizer, as employed in hospitals in those days. It is a mechanical component which serves to seal gas or compressed-air tanks and thereby to regulate the pressure within. Lying in hospital, Frida Kahlo may have seen a parallel between this sealing mechanism and her own "faulty" muscles, which prevented her from keeping the child in her womb.

The purple orchid in the centre below the bed was brought to her in hospital, according to Frida Kahlo, by Diego Rivera. For her, the orchid was a symbol of sexuality and emotions.

The loneliness and helplessness evoked by the small figure of the artist, so utterly vulnerable in an enormous bed before a vast plain, surely reflect Frida Kahlo's own feelings following the loss of her child and during her stay in hospital. This impression is reinforced by the desolate industrial landscape on the horizon, against which

the bed appears to float. It is the Rouge River complex in Dearborn/Detroit, part of the Ford Motor Company. The Riveras had visited it together, since Rivera wanted to make studies there for his *Man and Machine* mural for the Detroit Institute of Arts. The Rouge River complex indicates the city in which the traumatic event took place. A symbol of technological progress, it stands in crass contrast to the human fate of the artist.

Although the individual motifs within the picture are rendered in accurate detail, true-life realism is avoided in the composition as a whole. Objects are extracted from their normal environment and integrated into a new composition. It is more important to the artist to reproduce her emotional state in a distillation of the reality she had experienced than to record an actual situation with photographic precision.

The extraction and re-integration of essential, meaningful elements is a characteristic feature of Mexican votive art. Indeed, many parallels can be drawn between the style, size and materials employed by Frida Kahlo and those of ex-voto painting. Like most votive pictures of the 19th and 20th century, *Henry Ford Hospital* is executed in oil on metal and has a small format. But while ex-votos generally depict the saints to whom they are dedicated in the upper, sky region of the composition, surrounded by an aureole of fluffy cloud, here they are omitted altogether. Their place is taken instead by the floating symbols with a quite different significance. The work nevertheless represents, like a votive image, the depiction of a calamity. And just as Frida Kahlo has done here, votive paintings commonly portray specific objects, textiles and decorative elements in precise detail, and employ landscapes and architecture purely as backdrop, without perspective depth. Although the work bears no dedication from a donor or written description of the accident, it makes reference to such votive inscriptions in the date and place of events given on the sides of the bed.

Even if the ex-voto elements of *Henry Ford Hospital* were not employed in their original spirit, the painting is nevertheless closely related to votive images. This emerges most clearly, as in many other of her pictures, in its combination of biographical fact and fantasy. Like the amateur painters of votive pictures, Frida Kahlo did not paint her reality as it was seen, but as she felt it. The outside world is thereby reduced to its essentials, and a sequence of events condensed into a powerful climax.

The artist owned a large collection of ex-voto panels. These came from churches closed by the authorities following the Revolution, where they had once been hung by the faithful in supplication or thanksgiving to the Virgin and other saints. Of the older works of this kind, originally painted on wood or canvas by anonymous, untrained artists, only a small number still survive today. The cheaper and more durable material of metal did not come into use until the 19th century.

Frida Kahlo began employing the small-format metal panels

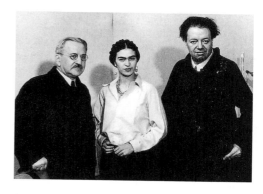

Architect Albert Kahn, Frida Kahlo and Diego Rivera, photographed in 1932 in the Detroit Institute of Arts, where Rivera had been commissioned to paint murals.

Exquisite Corpse, around 1932
(cf. ill. p. 34 below)

common to ex-votos from 1932 onwards, above all for her self-portraits, where the problems she portrays share the individual and highly personal character of votive pictures. She thereby employs a similar compositional structure, adopts the same simplicity of form and reduces her subject to its essentials. Centralized perspective and correct proportioning are neglected in favour of scenic dramatization. There are no borders in her portraits between the familiar, real world, the objectively visible, and the world of the irrational and the imagination.

In March 1933, Diego having completed his murals, the couple left Detroit and spent the next nine months in New York, where Rivera had been awarded another commission. They had now been in America for almost three years, and Frida Kahlo was growing homesick for Mexico. She had already made clear her ambivalent feelings towards "Gringolandia" in her *Self-portrait on the Borderline between Mexico and the United States* (ill. p. 33) of 1932.

In an elegant pink dress and long, white lace gloves, she stands like a statue on a pedestal on the borderline between two different worlds. On the left, we recognize the ancient Mexican landscape, governed by the forces of nature and the natural life cycle, while on the right we see the dead, technology-dominated landscape of North America. Frida Kahlo finds herself torn between these two opposites. She holds a Mexican flag in one hand and a cigarette in the other. Despite her admiration for its industrial progress, the Mexican nationalist felt very uncomfortable in the New World. "I don't particularly like the gringo people", she wrote to a friend in Mexico. "They are boring and they all have faces like unbaked rolls (especially the old women)."[18] And in a letter to her friend Dr. Eloesser, she complains: "High society here turns me off and I feel a bit of rage against all these rich guys here, since I have seen thousands of people in the most terrible misery without anything to eat and with no place to sleep, that is what has most impressed me here, it is terrifying to see the rich having parties day and night while thousands and thousands of people are dying of hunger... Although I am very interested in all the industrial and mechanical development of the United States, I find that Americans completely lack sensibility and good taste. They live as if in an enormous chicken coop that is dirty and uncomfortable. The houses look like bread ovens and all the comfort that they talk about is a myth."[19]

The fact that her admiration for American technology was not uncritical, and that she was aware of the disadvantages of such "development", is reflected in her portrayal of the dead, cold world of industry in predominantly greys and blues. The Mexican world, on the other hand, is depicted in warm earthy and natural colours; flowers burst forth, and even the man-made products of sculpture and pyramid are built of natural materials. This contrast between the natural and the artificial appears throughout the composition. Thus the clouds in the Mexican sky have their counterpart in the smoke billowing from the factory stacks of the Ford works, while the rich flora

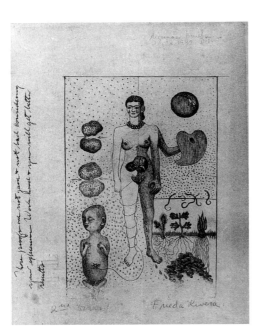

Frida and the Abortion
or *The Abortion,* 1932
Only three of the originally at least twelve proofs of this lithograph still survive today. This illustration shows the second proof. Frida Kahlo destroyed all the others herself. The hand-written notes in English on the left read: "These proofs are not good and not bad considering your experience. Work harder and you will get better results."

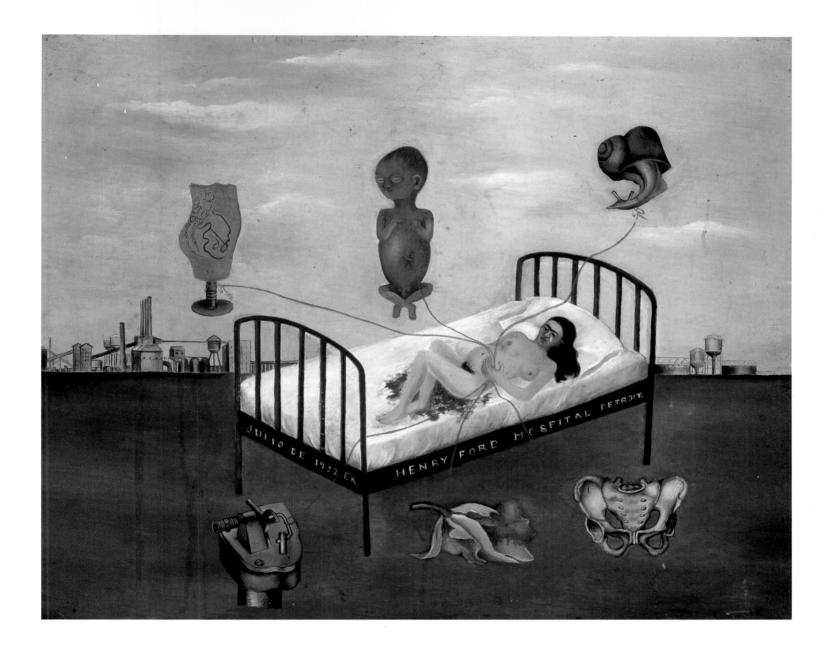

on the left gives way on the right to various items of electrical equipment, whose trailing cables become the roots through which they suck energy from the ground. Whereas the American industrial world appears lifeless, on the Mexican side two fertility dolls and a death's head together symbolize the cycle of life and death. In contrast to the gods of the USA, the industrialists, bankers and factory owners who dwell in skyscrapers, the modern-day city temples, we find on the left the ancient Mexican gods of Quetzalcoatl and Tezcatlipoca, here represented by the sun and moon over the ruins of a pre-Columbian temple.

There is just one link between the two worlds: an electricity generator standing on North American soil draws its power from the roots of a Mexican plant, which it then supplies to the socket on the pedestal on which Frida Kahlo is standing. Her figure thus appears to receive its energy from both worlds. This may be understood as an indication that the picture is more than just a statement of her current state of mind, her torn loyalties and homesickness for her native

Henry Ford Hospital
or *The Flying Bed,* 1932
On 4 July 1932 Frida Kahlo suffered a miscarriage in Detroit. The small, vulnerable figure of the artist lying in an enormous bed in front of a vast plain creates an impression of loneliness and helplessness – a reflection of her feelings following the loss of her baby and during her stay in hospital. The impression of forlornness is reinforced by the desolate industrial landscape on the horizon, against which the bed appears to float.

land; at another level, Frida Kahlo becomes the personification of Mexico itself, building upon its history and exploiting technological progress as it steers its own course between the two poles.

Serious disagreements arose between the couple before their return to Mexico. While Frida Kahlo had had enough of America and the Americans, Rivera remained fascinated by the country and did not want to leave. In reaction to the conflict, Frida Kahlo began work on *My Dress Hangs There* (ill. p. 34 above), which she later completed in Mexico. The only collage in the artist's oeuvre, it represents an ironic portrait of American capitalism. Filled with symbols of modern American industrial society, it points to social decay and the destruction of fundamental human values.

In an irony of fate, Rivera was released from his contract before its official expiry. He had given the figure of a workers' leader in his fresco the face of Lenin. In December 1933 he gave in to Frida's pressure and returned to Mexico with her. The couple moved into a new house in San Angel, then a southern suburb of Mexico City, which Rivera had commissioned from a friend, the architect and painter Juan O'Gorman. It was made up of two cuboids: Frida Kahlo lived in the smaller, blue one, while Diego Rivera set up a spacious studio in the larger, pink one.

Having done little work during her last year in America, Frida Kahlo – at last back in the surroundings she had yearned for – was ready to throw herself into painting. But health problems forced her back into hospital, and another pregnancy had to be terminated.

In 1935, too, she was only to produce two works, of which *A*

The goddess Tlazolteotl giving birth to a child. Aztec sculpture.

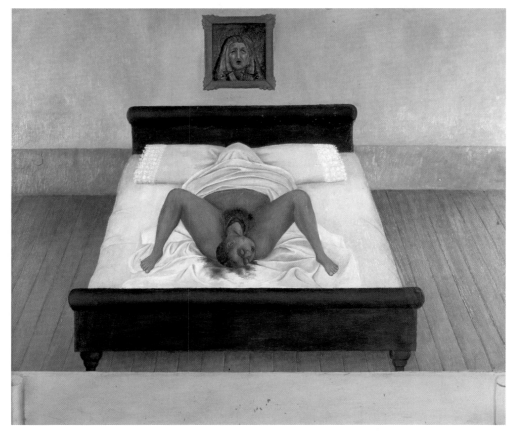

My Birth or *Birth,* 1932
Encouraged by Rivera, Frida Kahlo decided to document the major events of her life in a series of paintings. This first picture shows the artist's view of her own birth. It also points, however, to the miscarriage which she had suffered shortly before. The head of the mother is covered by a sheet – a reference to the death of her own mother while she was working on the picture.

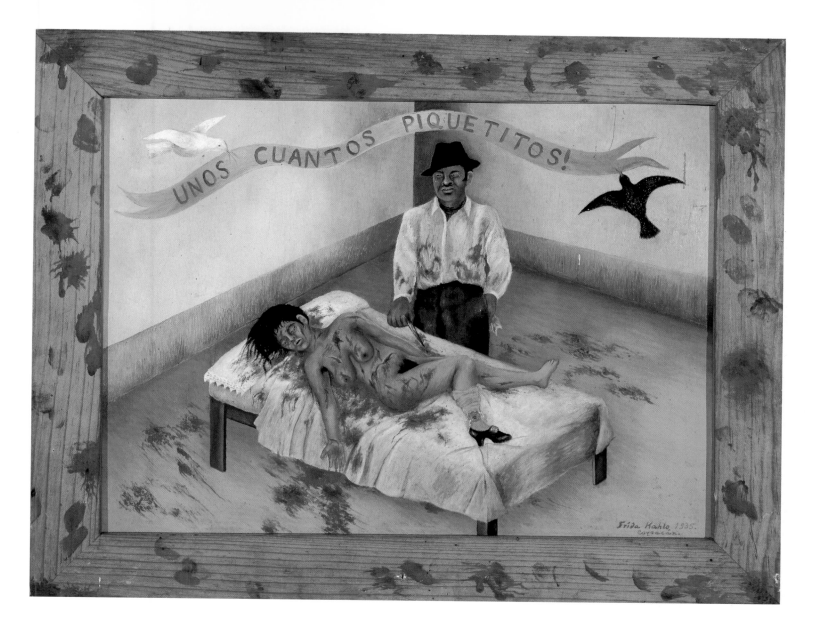

Few Little Pricks (ill. p. 39) is particularly striking for its bloody nature. It represents the visual transcript of a newspaper report about a woman murdered in an act of jealousy. The murderer had thereby defended his actions before the judge with the words: "But it was just a few little pricks!"

As in the case of most of her works, this gruesome representation of a murder must be viewed in the light of her own personal situation. Her relationship with Rivera during this period was so troubled that she was apparently only able to find release through the symbolism of her painting. Rivera, who had had repeated affairs with other women since their marriage, had now become involved with Frida's sister Cristina, who had modelled for him in two of his murals (ill. p. 15 right).

Profoundly hurt, Frida Kahlo left the couple's home at the beginning of 1935 and took an apartment in the centre of Mexico City. She contacted a lawyer friend, one of her former "Cachucha" comrades, in order to ask his advice about a possible divorce. Viewed in this light, *A Few Little Pricks* may be seen as an illustration of the

A Few Little Pricks, 1935
A newspaper report about a woman murdered in an act of jealousy provided the artist with the subject-matter for this work. The murderer had defended his actions before the judge with the words: "But it was just a few little pricks!" The violent deed makes symbolic reference to Frida Kahlo's own personal situation: her husband Rivera had recently started an affair with her sister Cristina.

Photograph of an excursion to Chapultepec Park in June 1938. From left to right: Leon Trotsky, Diego Rivera, Natalia Sedova (Trotsky's wife), Reba Hansen, André Breton, Frida Kahlo, Jean van Heijenoort.

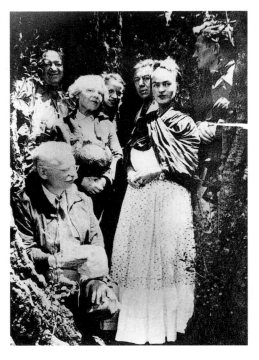

RIGHT:
Self-portrait dedicated to Leon Trotsky or ***"Between the Courtains"***, 1937
In 1937, while Trotsky and his wife, Natalia Sedova, were living in the Blue House in Coyoacán, a brief love affair developed between Trotsky and Frida Kahlo. After their relationship finished in July, the artist gave Trotsky this portrait, dedicated "with all love", for his birthday on 7 November, the anniversary of the Russian Revolution.

artist's mental state. The wounds caused by brutal male violence seem to symbolize her own emotional injuries.

In the middle of 1935 the artist escaped to New York with two American women friends to get away from her burdensome situation. When the relationship between Rivera and Cristina Kahlo finished, at the end of 1935, she returned to San Angel. The slate was wiped clean, although this did not mean that Rivera ceased his extramarital philandering. Instead, Frida Kahlo now started having her own affairs with other men, and – particularly in the later years of her life – with other women, too.

From 1936 Frida Kahlo renewed her political activities. July 1936 saw the outbreak of the Spanish Civil War; together with other sympathizers, she founded a solidarity committee in aid of the Republicans. Her political work gave her new drive and also brought her closer to Rivera, who had been sympathetic towards the Trotskyist League since 1933, when Leon Trotsky had started building up

the Fourth International. That same year, the couple petitioned the Mexican government to grant asylum to Leon Trotsky, who had been expelled from Norway as a result of pressure from Moscow. President Lázaro Cárdenas, who had been seeking to establish democratic conditions in Mexico since taking up his post in 1934, granted the asylum request.

On 9 January 1937, Natalia Sedova and Trotsky docked in Tampico, where they were met by Frida Kahlo. The artist placed at their disposal the Blue House, the Kahlo family home in Coyoacán, where the Trotskys lived until April 1939. The two couples spent many hours together, and a brief love affair flourished between Trotsky and Frida Kahlo. After their relationship finished in July 1937, the artist gave Trotsky the *Self-portrait dedicated to Leon Trotsky* (ill. p. 40) for his birthday on 7 November, the anniversary of the Russian Revolution. Dedicated "with all love", the work is executed in bright, friendly colours and exudes a fresh, positive atmosphere, prompting André Breton, six months later, to describe it in the following euphoric terms: "I have for long admired the self-portrait by Frida Kahlo de Rivera that hangs on a wall of Trotsky's study. She has painted herself in a robe of wings gilded with butterflies, and it is exactly in this guise that she draws aside the mental curtain. We are privileged to be present, as in the most glorious days of German romanticism, at the entry of a young woman endowed with all the gifts of seduction."[20]

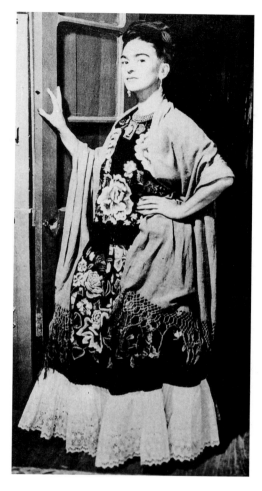

Frida Kahlo in the Blue House, around 1942. The house is situated in Coyoacán, a former suburb of Mexico City.

Jacqueline Lamba and André Breton arrived in Mexico in April 1938 and stayed for several months. For some of that time they lived with the Kahlo-Riveras in San Angel. Breton, one of the leaders of Surrealism, had been sent to lecture in Mexico by the French Ministry of Foreign Affairs. He, too, sympathized with the Trotskyist League and was very eager to meet Trotsky. He saw Mexico as the embodiment of Surrealism, and he also interpreted Frida Kahlo's works as Surrealist.

It was through this contact with Breton that Frida Kahlo was offered her first large exhibition abroad that same year. The difference between her art and that of the Surrealists was noted after this exhibition by Bertram D. Wolfe, who observed in an article published in "Vogue": "Though André Breton [...] told her she was a *surrealiste,* she did not attain her style by following the methods of that school. [...] Quite free, also, from the Freudian symbols and philosophy that obsess the official Surrealist painters, hers is a sort of 'naive' Surrealism, which she invented for herself. [...] While official Surrealism concerns itself mostly with the stuff of dreams, nightmares, and neurotic symbols, in Madame Rivera's brand of it, wit and humour predominate."[21]

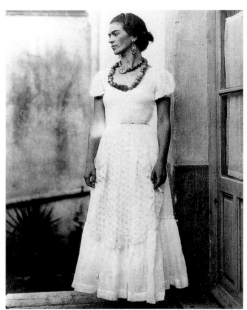

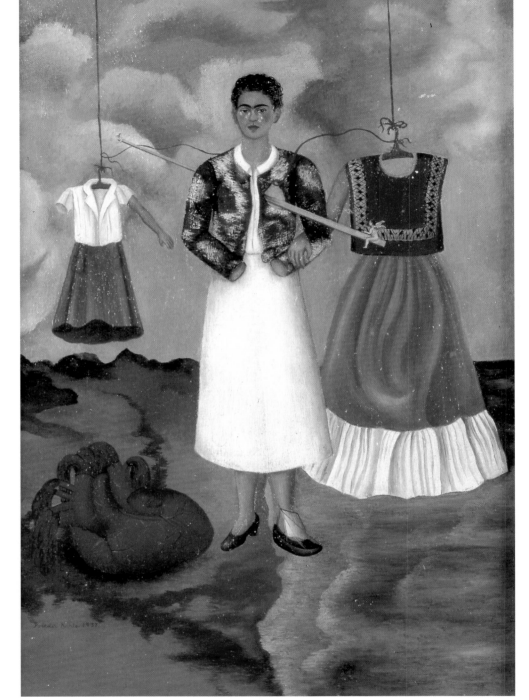

This photograph, taken around 1940, captures the typical Frida Kahlo, wearing the pre-Columbian necklaces which Rivera regularly gave her and holding a lighted cigarette in one hand.

Memory or **The Heart,** 1937
Frida Kahlo here finds a pictorial means to express the anguish which she suffered during the affair between her husband and her sister Cristina. Her broken heart lies at her feet; its disproportionate size symbolizes the intensity of her pain. She illustrates her feelings of helplessness and despair through her lack of hands. Frida Kahlo gave this painting to Michel Petitjean, head of the Renou and Colle gallery in Paris.

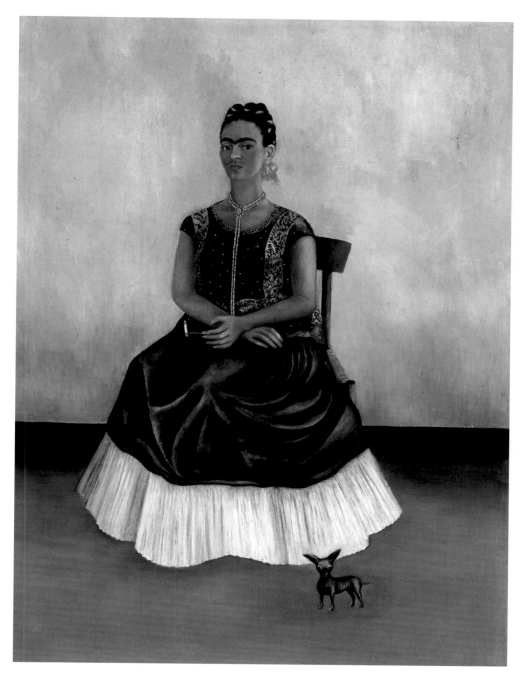

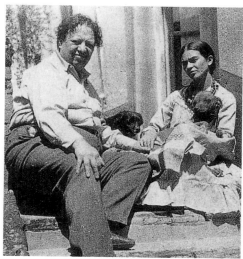

Self-portrait with Itzcuintli Dog,
around 1938
The picture shows a seductive young woman
with a full face and sensual lips. The mood is
nevertheless one of loneliness. Only the tiny
Itzcuintli dog offers Frida Kahlo the security
and affection which she frequently sought
from her many pets. An X-ray taken while the
picture was being restored has revealed an ear-
lier work beneath, featuring small birds and
plants around a pond.

Diego Rivera and Frida Kahlo with the
Itzcuintli dogs who, for Frida, came to replace
the children she never had.

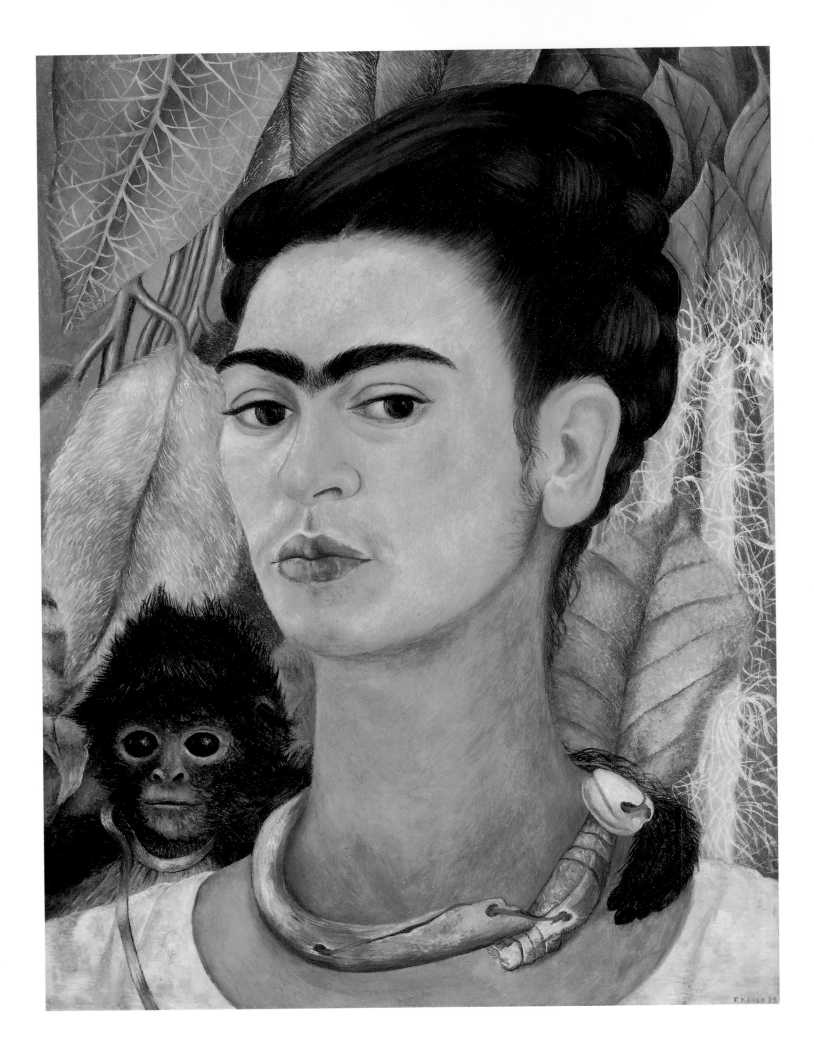

Despair and success

In early October 1938 Frida Kahlo travelled to the United States to prepare her forthcoming exhibition in Julien Levy's gallery. She had worked intensively for the past two years, and had taken part in a group exhibition in Mexico for the first time. Levy now proposed to stage a solo exhibition of her work in New York: "To my surprise, Julian [sic] Levy wrote me a letter, saying that somebody talked to him about my paintings, and that he was very much interested in having an exhibition in his gallery", the artist reported (in her own English) to her friend Lucienne Bloch. "I answered sending few photographs of my last things, and he send another letter very enthusiastic about the photos, and asking me for an exhibition of thirty things on October of this year. [...] I don't know what they see in my work", she mused. "Why do they want me to have a show?"[22]

Since Frida Kahlo had never painted with a public in mind, she could not quite understand what interest her work could have for others. She was similarly astonished when the American actor Edward G. Robinson purchased a large number of works the following summer: "I kept about twenty-eight paintings hidden. While I was on the roof terrace with Mrs. Robinson, Diego showed him my paintings and Robinson bought four of them from me at two hundred dollars each. For me it was such a surprise that I marveled and said: 'This way I am going to be able to be free, I'll be able to travel and do what I want without asking Diego for money.'"[23]

All the more reason, then, for Frida Kahlo to enjoy her trip to the States, which she made alone. Despite a lack of concrete evidence, friends and acquaintances assumed that she had separated from Diego. She flirted freely with her admirers and entered a very intimate and passionate affair with the photographer Nickolas Muray.

Since the number of art galleries in those days was still only small — and the number devoted to the avant-garde even smaller —, the opening of the exhibition proved a major cultural event. For a first solo exhibition it was a considerable success, and received remarkable coverage in the press. Despite the economic depression affecting the United States, half of the twenty-five works on display (which included some purely on loan from private collections) were sold. A number of visitors commissioned new works from the artist,

Self-portrait dedicated to Marte R. Gómez, 1946
Marte R. Gómez was an agrarian engineer and then Minister of Agriculture. He was a close friend of Frida Kahlo's, and she also painted his own portrait.

Self-portrait with Monkey, 1938
In Mexican mythology the monkey is the patron of the dance, but also a symbol of lust. Here, however, the artist portrays the animal in such a way that it becomes the only truly living, tender and soulful being, its arm placed protectively around her neck. The picture was commissioned by A. Conger Goodyear, then president of the Museum of Modern Art in New York, following an exhibition of her work in Julien Levy's gallery in October 1938. He had originally wanted to purchase the picture *Fulang Chang and I,* but Frida Kahlo had already given this to Mary Schapiro Sklar.

The Mask, 1945
Many of the artist's self-portraits suggest that the face shown is in fact a mask, behind which her true feelings are hidden. In *The Mask* this principle is reversed: a papier-mâché mask shows the feelings which Frida Kahlo's face does not otherwise reveal.

This photograph of a suckling infant was taken by Frida Kahlo's friend, the Communist photographer Tina Modotti (1896–1942). Modotti won great international acclaim for her social commentary and her documentary and propagandist photography.

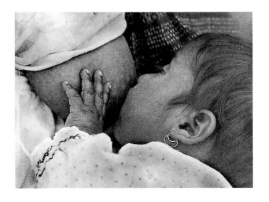

amongst them A. Conger Goodyear, then president of the Museum of Modern Art in New York. He was extremely taken by the picture *Fulang Chang and I,* which was on show in the exhibition, but which Frida Kahlo had already given to her friend Mary Schapiro Sklar, sister of the art historian Meyer Schapiro. He therefore commissioned her to execute a similar work. She completed her *Self-portrait with Monkey* (ill. p. 44) in her hotel room while still in New York.

A new painting was also commissioned by Clare Boothe Luce, publisher of the fashion magazine "Vanity Fair". Her friend Dorothy Hale, an actress with whom Frida Kahlo had also been acquainted, had committed suicide in October 1938. "A short while after that, I went to a gallery exhibition of Frida Kahlo's paintings", the publisher recalled. "The exhibition was crowded. Frida Kahlo came up to me through the crowd and at once began talking about Dorothy's suicide. [...] Kahlo wasted no time suggesting that she do a *recuerdo* of Dorothy. I did not speak enough Spanish to understand what the word *recuerdo* meant. [...] I thought Kahlo would paint a portrait of Dorothy in the style of her own self-portrait [dedicated to Trotsky], which I bought in Mexico (and still own). [...] Suddenly it came to me that a portrait of Dorothy by a famous painter friend might be something her poor mother might like to have. I said so, and Kahlo thought so too. I asked the price, Kahlo told me, and I said 'Go ahead. Send the portrait to me when it is finished. I will then send it on to Dorothy's mother.'"[24]

Thus arose Frida Kahlo's painting of *The Suicide of Dorothy Hale* (ill. p. 50), the documentation of a real event in the form of an ex voto. Dorothy Hale had thrown herself from the window of an apartment block. As in a multiple-exposure photograph, Frida Kahlo records the various stages of her fall, placing the corpse at the bottom on a stage-like platform in the foreground plane, detached from the building behind. The story of events is related in blood-red lettering in the inscription at the bottom: "In the city of New York on the 21st day of the month of October, 1938, at six o'clock in the morning, Mrs. Dorothy Hale committed suicide by throwing herself out of a very high window of the Hampshire House building. In her memory [now comes a blank space where the words have been painted out] this *retablo,* executed by Frida Kahlo."

Dorothy Hale, whose husband Gardiner Hale, an established portrait painter in American high society, had been killed in a car crash in the mid-thirties, was in severe financial difficulties. She could no longer afford the lavish life-style of her married years. She tried her luck in Hollywood, but failed the screen tests and was forced to live on the charity of her friends. In the course of her repeated attempts to find work, she was told that – at thirty-three – she was too old for a professional career. Rather than looking for a job, she should look for a wealthy husband. Shortly before her suicide she invited all her friends round, telling them she had decided to go on a long trip and was therefore holding a farewell party.

"In the early morning of the day after the party, the police tele-

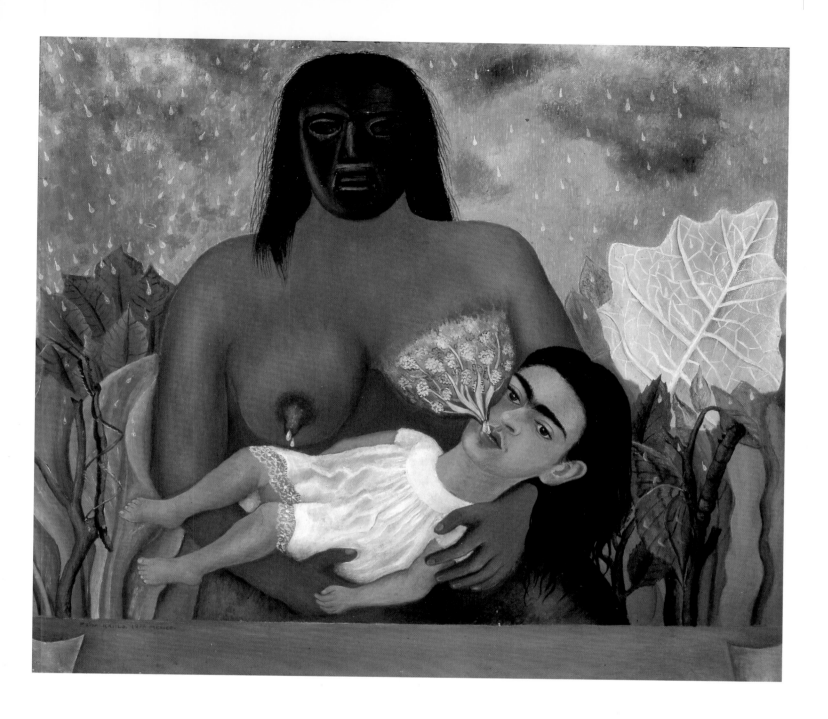

phoned", remembered her friend and benefactress. "At about 6.00 A.M., Dorothy Hale had jumped out of the window of her top-story suite in the Hampshire House. [...] She was wearing my favourite – her black velvet 'femme fatale' dress, and a corsage of small yellow roses, which Isamu Noguchi [a sculptor with whom Frida Kahlo was good friends and had also had an affair], it turned out, had sent to her." This is precisely the outfit in which she appears in Frida Kahlo's painting.

When Clare Boothe Luce received the picture, she seriously considered destroying it. "I will always remember the shock I had when I pulled the painting out of the crate. I felt really physically *sick*. What was I going to do with this gruesome painting of the smashed corpse of my friend, and her blood dripping down all over the frame? I could not return it – across the top of the painting there was an an-

My Nurse and I or *I suckle,* 1937
Frida Kahlo's mother was unable to breastfeed her, because her sister Cristina was born just eleven months after her. She was therefore fed by a wet-nurse. The relationship shown here appears distanced and cool, reduced to the practical process of feeding, an impression heightened by the lack of eye contact and the mask in front of the nurse's face. The artist considered this one of her most powerful works.

47

ILLUSTRATION PAGE 49:

What I Saw in the Water or
What the Water Gave Me, 1938
This painting is a symbolic work
illustrating various events from
the artist's life and incorporating
numerous elements from other
works. Frida Kahlo developed
her own, highly personal pictorial language. Although many of
her works contain surreal and
fantastical elements, they cannot
be called Surrealist, for in none
of them does she entirely free
herself from reality.

The Two Fridas, 1939 (ill. p.53)

Page from her diary (ill. p. 90)

The Dream or ***Self-portrait, dreaming*** (I),
1932

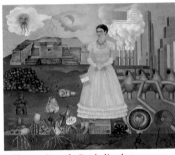

***Self-portrait on the Borderline between
Mexico and the USA,*** 1932 (ill. p. 33)

"They thought I was a Surrealist,
but I wasn't. I never painted
dreams. I painted my own reality."
FRIDA KAHLO

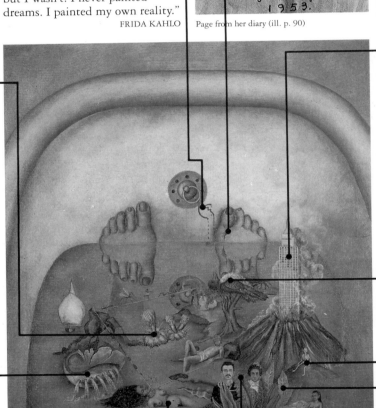

Hieronymus Bosch
The Garden of Delights (detail)

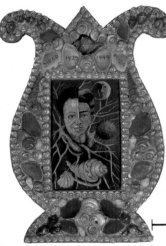

Diego and Frida 1929–1944 (I), 1944 (ill.
p. 67)

Memory, 1937 (ill. p. 42)

Four Inhabitants of Mexico City, 1938

Max Ernst
The Nymph Echo, 1936

Two Nudes in the Forest, 1939 (ill. p. 56)

Henry Ford Hospital, 1932 (ill. p. 37)

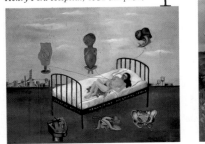

My Grandparents, My Parents and I, 1936
(ill. p. 9)

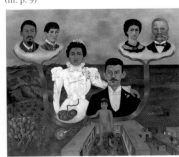

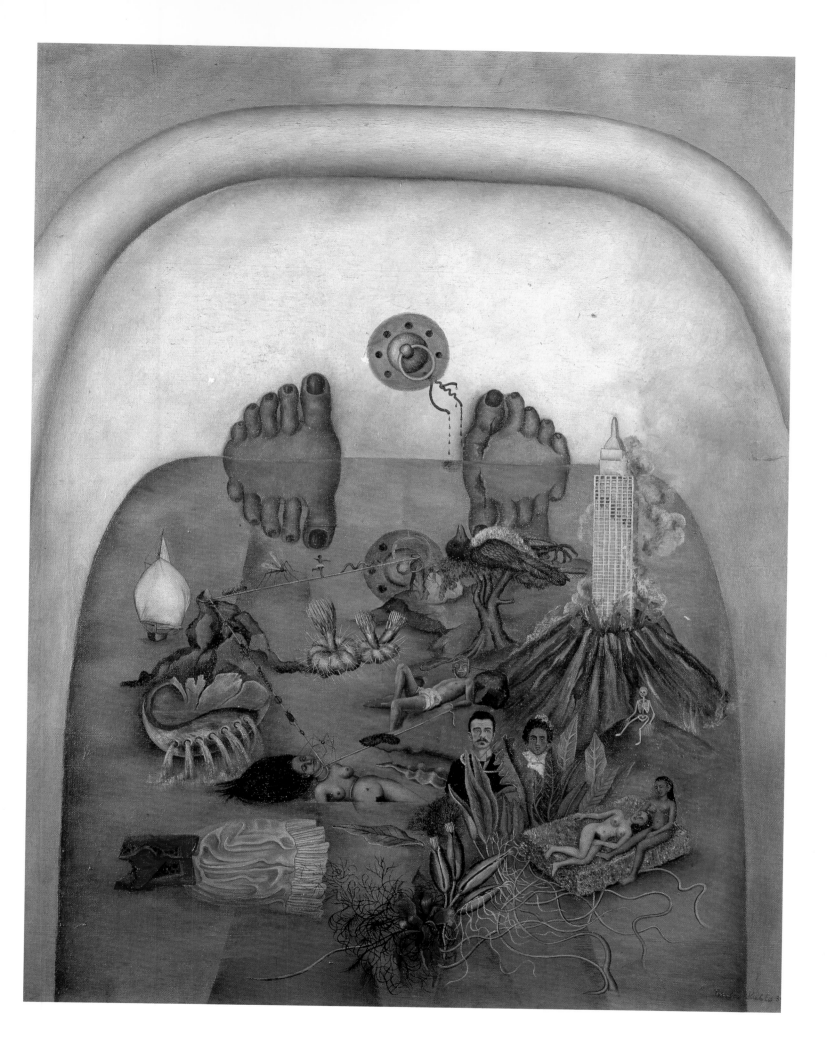

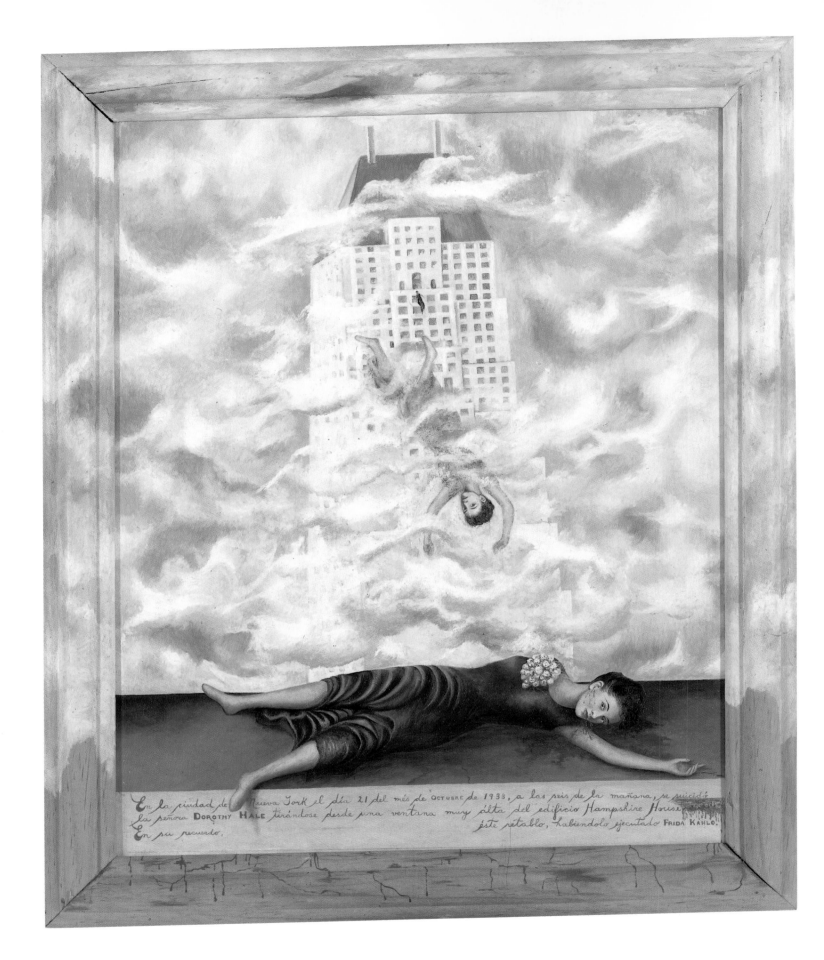

En la ciudad de Nueva York el día 21 del més de OCTUBRE de 1938, a las seis de la mañana, se suicidó la señora DOROTHY HALE tirándose desde una ventana muy álta del edificio Hampshire House. En su recuerdo [...] éste retablo, habiendolo ejecutado FRIDA KAHLO.

gel waving an unfurled banner which proclaimed in Spanish that this was 'The suicide of Dorothy Hale, painted at the request of Clare Boothe Luce, for the mother of Dorothy'. I would not have requested such a gory picture of my worst enemy, much less of my unfortunate friend."

Eventually, the publisher allowed herself to be persuaded by friends not to destroy the picture, but to have the banderole painted over. Part of the inscription was similarly painted out to enable the picture's sponsor to distance herself from this "gruesome" work.

In January 1939 Frida Kahlo sailed for Paris. André Breton, whose prompting had encouraged Levy to exhibit her work, had decided to hold his own show in Paris at the start of the year. But when the artist arrived, she found that Breton had yet to take any practical steps towards arranging the promised exhibition. Her works had not been cleared through customs, and no suitable gallery had been found. It was only with the help of Marcel Duchamp, whom Frida Kahlo called "(...) the only one who has his feet on the earth, among all this bunch of coocoo lunatic sons of bitches of the Surrealists "[25], that she managed to complete all the necessary preliminary arrangements. Renou et Colle, a well-known gallery specializing in Surrealist art, agreed to provide the rooms, and the "Mexique" exhibition eventually opened on 10 March 1939, accompanied by a catalogue. Frida Kahlo's works appeared alongside Mexican works from the 18th and 19th century, as well as photographs by Manuel Alvarez Bravo, pre-Columbian sculptures from Diego Rivera's collection and numerous folk-art objects which Breton had purchased in Mexican markets.

After this bad start, the artist's impressions of Paris never really improved. Although interested to meet the circle of artists around Breton, she was very disillusioned by the Surrealists: "You have no idea the kind of bitches these people are", she wrote to Nickolas Muray in February, full of contempt for the Parisian artists. "They make me vomit. They are so damn 'intellectual' and rotten that I can't stand them any more. [...] It was worthwhile to come here only to see why Europe is rottening, why all this people – good for nothing – are the cause for all the Hitlers and Mussolinis. I bet you my life I will hate this place and its people for as long as I live."

It is hard to imagine that the Surrealists alone were the cause of her ill humour. Overshadowed by the threat of war, the exhibition was not a financial success. For this reason she cancelled a follow-on exhibition which was to have been held in the Guggenheim Jeune gallery in London. She saw no point in showing her art at a time when the Europeans were preoccupied with quite different matters. It was Jacqueline Lamba's belief, however, that the French were simply too nationalistic to be interested in the works of a largely unknown foreigner. Moreover, she felt that: "Women were still undervalued. It was very hard to be a woman painter."[26]

The exhibition nevertheless received a very favourable review in the magazine "La Flèche", and one painting – the Self-portrait "The

Portrait of Diego Rivera, 1937
"She [is] the first woman in the history of art to treat, with absolute and uncompromising honesty, one might even say with impassive cruelty, those general and specific themes which exclusively affect women." DIEGO RIVERA

The Suicide of Dorothy Hale, 1938/39
Clare Boothe Luce, publisher of the fashion magazine "Vanity Fair", commissioned Frida Kahlo to paint a portrait of her friend, the actress Dorothy Hale, with whom Frida Kahlo had also been acquainted. Hale had committed suicide in October 1938 by jumping out of the window of her high-rise apartment. When Clare Booth Luce received the picture, she seriously considered destroying it. She would not have requested such a gory picture of her worst enemy, much less of her unfortunate friend, she later said in an interview.

Self-portrait, drawing, around 1937
Frida Kahlo kept a number of mirrors positioned around her easel which she used when painting her self-portraits. She therefore appears holding her pencil in her left hand, although in reality she painted and drew with her right hand.

Frame (ill. p. 30) – became the first work by a 20th-century Mexican artist to be purchased by the Louvre. It has been in the possession of the French nation ever since. It had been reproduced in colour in "Vogue" during the exhibition in New York, and a picture of Frida Kahlo's ring-bedecked hand used for the cover. The artist's exotic appearance later prompted Schiaparelli to create a "Robe Madame Rivera" based on her Tehuana costumes. Both the artist and her work thus received a great deal of publicity.

Frida Kahlo left France just two days after the exhibition closed. After a stopover in New York, she was back in Mexico before the month was out. Increasingly estranged from Diego Rivera, she left their home in San Angel in summer 1939 and went to live with her parents in Coyoacán. That same autumn the couple filed for divorce, which was granted on 6 November 1939.

The self-portrait *The Two Fridas* (ill. p. 53), which shows a Frida Kahlo composed of two different personalities, was completed shortly after the divorce, and processes the emotions surrounding her separation and marital crisis. The part of her person which was respected and loved by Diego Rivera, the Mexican Frida in Tehuana dress, holds in her hand an amulet bearing a portrait of her husband as a child; the same amulet was found amongst the artist's possessions after her death and is now on display in the Museo Frida Kahlo. Beside her sits her *alter ego,* a rather more European Frida in a lacy white dress. The hearts of the two women are exposed, connected by just one fragile artery. The two ends of their other artery are separate. With the loss of her beloved, however, the European Frida has lost part of her own self. Blood drips from the freshly-severed artery and is only barely kept in check with a surgical clamp. The rejected Frida is in danger of bleeding to death.

"I had tea with Frida Kahlo de Rivera in the house where she was born", wrote the art historian MacKinley Helm, "...on the December day in 1939 when there was handed into the studio a set of papers announcing the final settlement of her divorce from Rivera. Frida was decidedly melancholy. It was not she who had ordained the dissolution of the marriage, she said; Rivera himself had insisted upon it. He told her that separation would be better for them both, and had persuaded her to leave him. But he had by no means convinced her that she would be happy, or that her career would prosper, apart from him."[27] The separation brought on other problems. "Her despair is leading her to drink heavily"[28], wrote Henriette Begun in her medical report.

During this period of loneliness, Frida Kahlo threw herself into work. Since she wanted no further financial support from Diego Rivera, she sought to earn her own living through painting. "I will never accept money from any man till I die"[29], she announced confidently. The following few years saw a series of self-portraits whose similarity – almost identicalness – is striking. They are differentiated solely by the attributes which surround them, by their backgrounds and by their palette, influenced by Mexican popular art. The artist

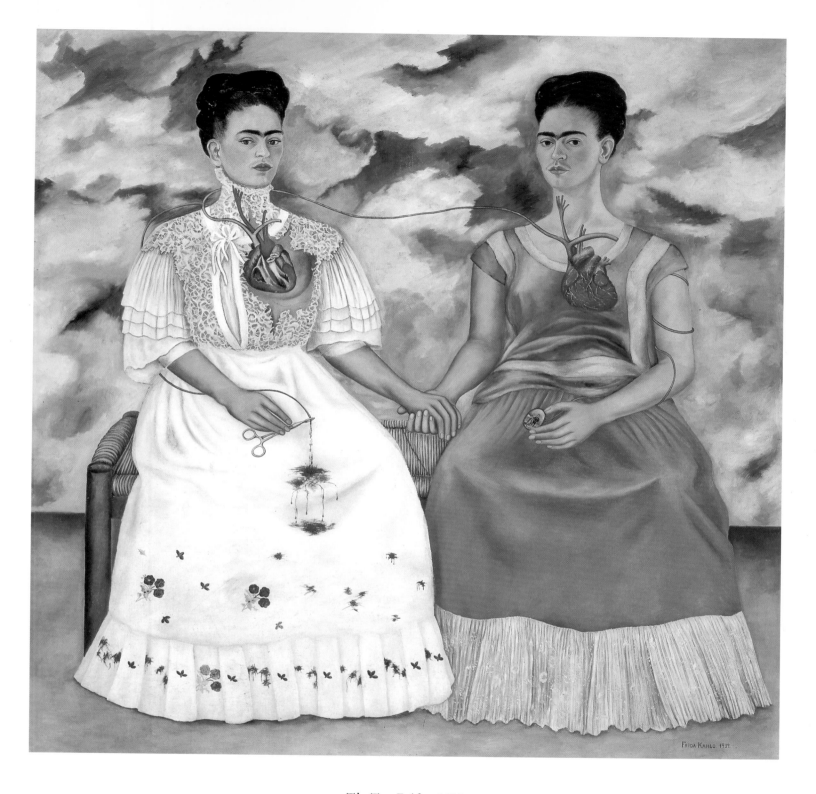

The Two Fridas, 1939

Shortly after her divorce from Diego Rivera, Frida Kahlo completed a self-portrait composed of two different personalities. In this picture she processes the emotions surrounding her separation and marital crisis. The part of her person which was respected and loved by Diego Rivera is the Mexican Frida in Tehuana costume, while the other Frida wears a rather more European dress. The hearts of the two women lie exposed, and are connected by just one artery. The rejected, European part of Frida Kahlo is in danger of bleeding to death.

manipulates these varying elements to express different moods, which at the same time conceal the almost mass-produced, sales-oriented nature of their production. The contrast in these portraits between the lavish accessories, richly-decorative clothing and hair-styles and the introspective, serious, frozen face of the sitter creates a remarkable tension, as if the face were a mask behind which the artist's true feelings are hidden. In the self-portrait *The Mask* (ill. p. 46 above), this principle is reversed: the papier-mâché mask shows the feelings which the face will not reveal. The face becomes the mask, and the mask the face.

The artist's new-won independence is also the subject of her *Self-portrait with Cropped Hair* (ill. p. 54). In place of the very feminine clothes seen in most of her self-portraits, she here appears dressed in a large, dark-coloured man's suit. She has just cut off her long hair – we see the scissors still in her hand. One of the tresses lies over her thigh, while the remaining strands and plaits twist and curl their way across the floor and round the legs of the chair, as if they had a life of their own. The verse of a song painted across the top of the picture points to the reason behind this act of self-mutilation: "See, if I loved you, it was for your hair; now that you're bald, I don't love you any more." The text is taken from a Mexican song which was popular in the early forties, and is illustrated almost jokingly by the scene below.

Frida Kahlo, who felt she was loved, as in the song, only for her female attributes, decided to put these aside and renounce the feminine image demanded of her. She cut off her hair, symbol of womanly beauty and sensuality, as she had done during her previous separation from Rivera in 1934/35. She also gave up the Tehuana costumes so liked by her husband and wore instead a man's suit, its cut so broad that it might well have stemmed from Rivera's own wardrobe. Her only clearly feminine attribute remain her earrings.

A further connection between the act of cutting off her hair and her divorce from Rivera is suggested by her *Self-portrait with Braid* (ill. p. 60), which she painted shortly after remarrying Rivera in December 1940. It shows the artist with her hair done up in a style very similar to that worn by the *indígenas* in the northern region of Oaxaca state and in Sierra Norte de Puebla. Her hair, combed tightly back against her scalp, is plaited with red wool into an elaborate bow, which sits on her head like a head-dress. But her wild hair cannot fully be tamed, and wisps and tufts dart in and out of the plait at various points. The strands of hair littering the floor of the first picture have clearly been gathered up again in the second and plaited into a new braid which, in its shape of an endless loop, might be seen as a symbol of the eternal circle of time. This idea is reinforced by the acanthus leaves entwined around the naked upper body of the artist (due to its perennial growth, the acanthus plant has served as a symbol of eternal life since ancient times). Thus the femininity which she rejected and symbolically renounced in 1940 Frida Kahlo now takes up again one year later.

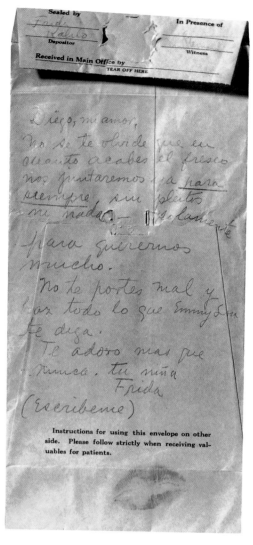

Love-letter from Frida Kahlo to Rivera, before 1940
Diego, my darling,
don't forget that as soon as you've finished the fresco, we'll be united <u>for ever,</u> without rows or whatever – simply to love each other very much.
Don't misbehave yourself and do everything Emmy Lou tells you.
I love you more than ever before. Your little girl Frida
(Write to me)

Self-portrait with Cropped Hair, 1940
In place of the decidedly feminine clothes seen in most of her self-portraits, Frida Kahlo here appears dressed in a large, dark suit. She has just cut off her long hair with the scissors. The verse of a song painted across the top of the picture points to the reason for her act: "See, if I loved you, it was for your hair; now you're bald, I don't love you any more."

Towards the end of 1939 she began to suffer increased back pain and developed an acute fungal infection on her right hand. At the recommendation of Dr. Eloesser, in September 1940 Frida Kahlo travelled to San Francisco to see him for treatment. In thanks for the therapy which stabilized her condition, she painted the *Self-portrait dedicated to Dr. Eloesser* (ill. p. 59), which she signs "with all love" in the dedication in the white banderole held by a hand in the lower half of the picture. The hand shape reappears in the artist's earring. It recalls Mexican *milagros,* votive gifts made of metal, wax or ivory offered in thanksgiving to the saints for their help in times of crisis. In this case it represents the source of the artist's complaint, her infected hand. The doctor has freed her from her suffering, the memory of which lives on in the Crown of Thorns pricking her neck. The thorns are simultaneously a pre-Columbian symbol of resurrection and rebirth, and stand for release from pain. This same theme is taken up in the leafy background where, alongside dead and withered branches, we see a number of shoots carrying young white buds, indicating their renewed vitality.

Diego Rivera was also in San Francisco at this time. He had been commissioned to paint a mural for the Golden Gate International Exposition. When, in December, he asked Frida Kahlo to marry him a second time, she immediately agreed. "Our separation", said the mural painter, "was having a bad effect on both of us."[30] As a condition of their remarriage, however, Frida Kahlo insisted "that she would provide for herself financially from the proceeds of her own

Two Nudes in the Forest or *The Earth Itself* or *My Nurse and I,* 1939
The artist's ambivalent sexuality serves as the motif for a number of paintings. Frida Kahlo had several lesbian friends and made no attempt to conceal her bisexuality. Although, in his jealousy, Rivera couldn't bear his wife having affairs with other men, he sanctioned her women lovers. This picture was a gift from Frida Kahlo to her friend, the film star Dolores del Rio.

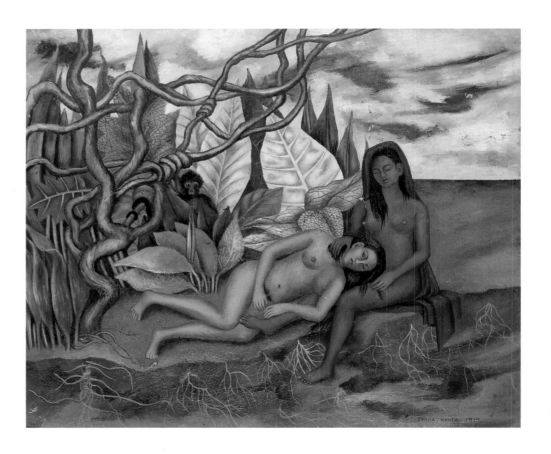

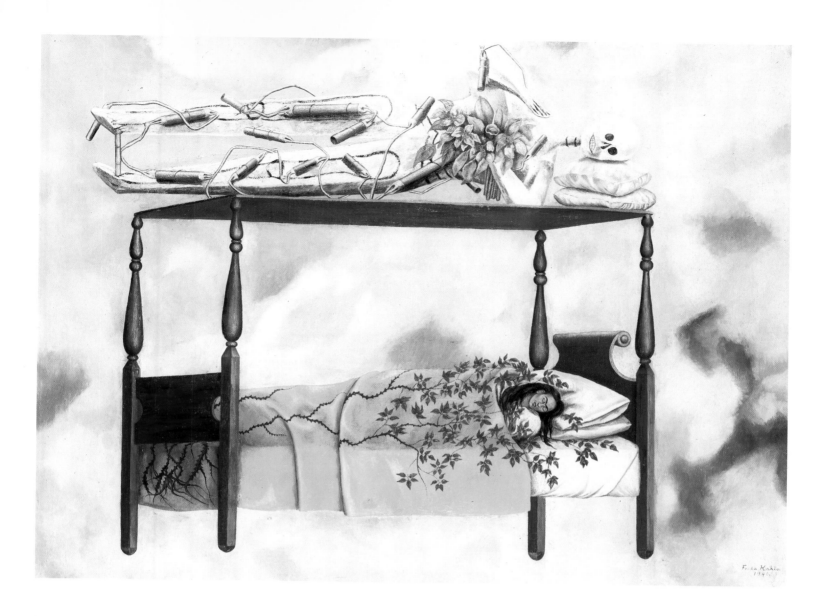

work; that I would pay one half of our household expenses – nothing more; and that we would have no sexual intercourse. [...] I was so happy to have Frida back that I assented to everything". In San Francisco on 8 December 1940, Diego Rivera's birthday, they were married a second time.

The artist returned to Mexico shortly afterwards. Rivera followed her in February 1941, having completed his commission, and moved into the Blue House in Coyoacán where Frida was already living. He continued to use the house in San Angel as his studio. The relationship between husband and wife had changed. Frida Kahlo had gained self-confidence and financial and sexual independence and was a recognized artist.

The Dream or *The Bed,* 1940
The figure above the canopy of the bed represents Judas. Such Judas figures are exploded in the streets of Mexico on Easter Saturday, since it is believed that the traitor will only find release in suicide. Frida Kahlo and Diego Rivera had a number of Judas figures in their sculpture collection.

ILLUSTRATION PAGE 58:
Frida Kahlo, photographed around 1938/39 by her lover, Nickolas Muray.

ILLUSTRATION PAGE 59:
Self-portrait dedicated to Dr. Eloesser, 1940
On the banderole at the bottom, the dedication (translated) reads: "I painted my portrait in the year 1940 for Doctor Leo Eloesser, my doctor and my best friend. With all love. Frida Kahlo."

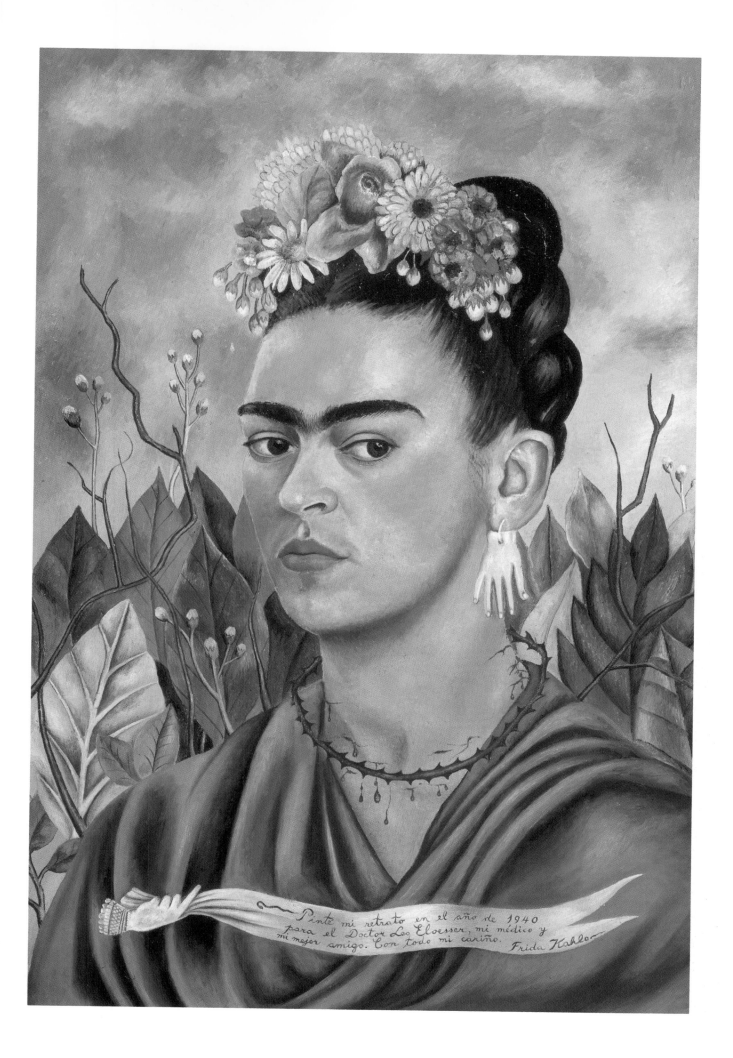

Pinté mi retrato en el año de 1940
para el Doctor Leo Eloesser, mi médico y
mi mejor amigo. Con todo mi cariño.
Frida Kahlo

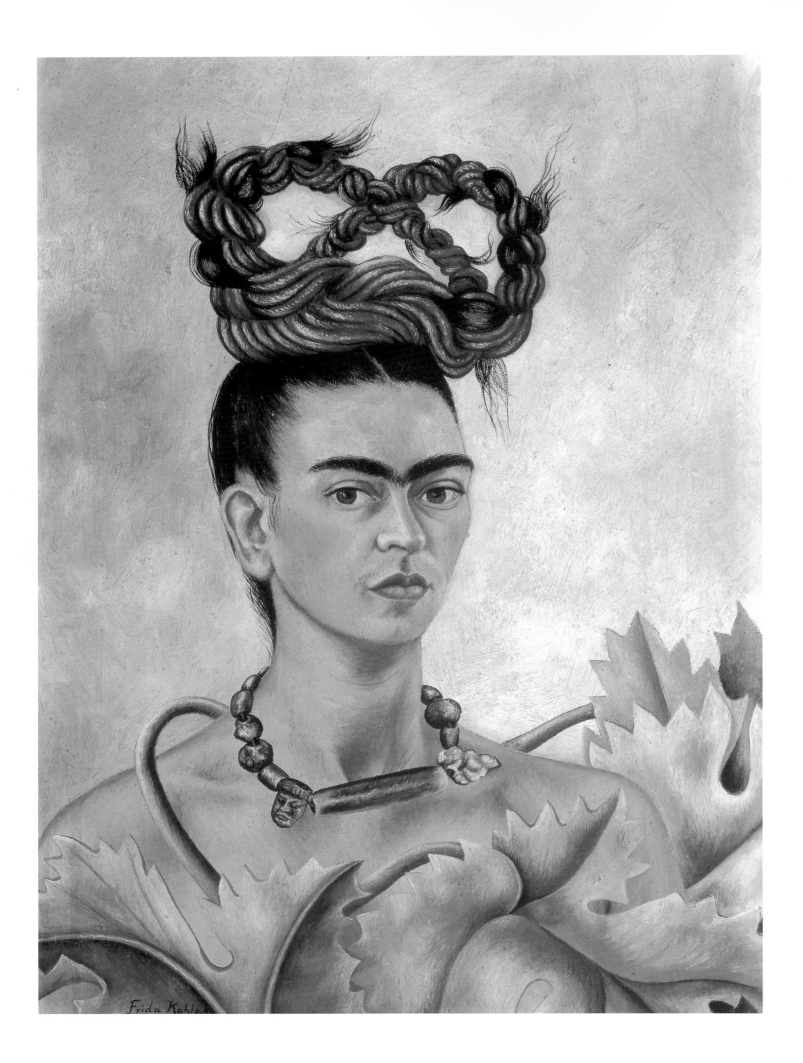

"These surgeon sons of bitches"

After her second marriage to Diego Rivera, Frida Kahlo's life settled into a somewhat calmer routine. "It was these ordinary things of life – animals, children, flowers, the countryside – that most interested Frida"[31], recalled Emmy Lou Packard, one of Rivera's assistants, who lived with the couple in Coyoacán for a while. And indeed, in many of the self-portraits of the early forties, the artist is joined by one or several of her domestic pets – parrots, monkeys and Itzcuintli dogs (ills. p. 64 and p. 65).

In 1942 she began writing a diary, one of the most important keys to her feelings and thoughts. She not only recorded her experiences chronologically from the forties right up to the end of her life, but reflected back upon her childhood and youth. She discussed such topics as sexuality and fertility, magic and esotericism, and her mental and physical suffering. She also captured her moods in watercolour and gouache sketches, which Hayden Herrera considers to be the most truly surrealist, albeit the lesser known, of the artist's works.

The world political situation was growing increasingly explosive. The war in Europe was persisting, and in 1941 the Germans invaded Russia. Stalin's opposition to Hitler brought Frida Kahlo closer to the Communist Party. The Second World War prompted an economic boom in Mexico, whose raw materials were in heavy demand for the American armaments industry. At the same time, under the presidency of Manuel Avila Camacho (1940–1946), the country underwent a swing to the right, a development which was to affect cultural policy in particular. It was nevertheless during this same period that Frida Kahlo began to receive greater public recognition in Mexico. She was appointed to committees, offered a teaching contract, awarded a prize and invited to contribute to magazines. The growth of her reputation followed the International Exhibition of Surrealism, which opened on 17 January 1940 in Mexico's first private art gallery, the Galería de Arte Mexicano run by Inés Amor. The exhibition was organized by André Breton, the Peruvian writer César Moro, the Austrian painter Wolfgang Paalen and the French artist Alice Rahon. Frida Kahlo showed *The Two Fridas* (ill. p. 53). She went on to participate in numerous group exhibitions in Mexico and the USA over the course of the forties.

In 1942 she was elected a member of the Seminario de Cultura

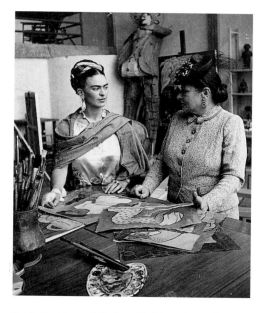

Frida Kahlo and Helena Rubinstein, selling works by Diego Rivera, around 1940.

Self-portrait with Braid, 1941
The act of cutting off her hair expressed more than simply the pain occasioned by her divorce from Rivera. In this self-portrait, hair again becomes the vehicle through which she expresses her feelings following her remarriage to Rivera in December 1940. The strands of hair which littered the earlier picture (ill. p. 54) here seem to have been gathered up and plaited into a new braid. Frida Kahlo thus takes up again, one year later, the femininity which she rejected and symbolically renounced in 1940.

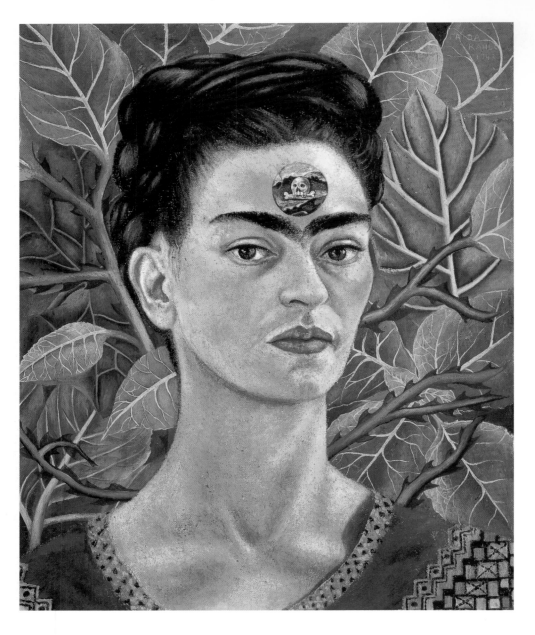

Thinking about Death, 1943
In the ancient Mexican sense, death simultaneously means rebirth and life. In this self-portrait, death is presented against a detailed background of thorny branches – a symbol derived from pre-Hispanic mythology through which the artist points to the rebirth that follows death. For death is understood as a path or transition to a life of a different kind.

Mexicana, a body which fell under the umbrella of the Ministry of Public Education and consisted of twenty-five artists and intellectuals. The Seminario's functions included promoting and spreading Mexican culture, organizing exhibitions and issuing publications.

Such was Frida Kahlo's reputation by the second half of the 1940s that her work featured in the majority of group exhibitions held in Mexico. Over the late thirties and early forties, her works assumed larger dimensions. This development was encouraged by the fact that, having become known to a wider audience through exhibitions, more of her paintings were executed as paid commissions. The forties in particular saw a noticeable increase in half-length portraits characterized by detailed backgrounds and accompanying attributes – a trend which may have something to do with the tastes of her clients, who perhaps preferred to spare themselves the confrontation with her – often shocking – full-length self-portraits presented in a narrative framework. One of the patrons who sporadically commissioned work from her was the agrarian engineer Eduardo Morillo

Portrait of Doña Rosita Morillo, 1944
One of the patrons who sporadically commissioned work from the artist was the agrarian engineer Eduardo Morillo Safa, who was employed in the diplomatic service. He purchased some thirty pictures from her over the years, and commissioned her to paint no less than five members of his family – amongst them his mother, Doña Rosita Morillo. This portrait was one of Frida Kahlo's favourite pictures.

Safa, who was employed in the diplomatic service. He purchased some thirty pictures from her over the years, and commissioned her to paint no less than five members of his family (ill. p. 63).

In 1942 the former College of Sculpture, under the administration of the Ministry of Public Education, was turned into a School of Painting and Sculpture. Its students quickly nicknamed it "La Esmeralda", after the street in which it stood. Art tuition was to be reformed, and to this end a new teaching staff of twenty-two artists was appointed, amongst them, as from 1943, Frida Kahlo. She taught a painting class for twelve lessons a week. As a consequence of the Mexican-nationalist convictions of the teachers, tuition proceeded very differently to other art colleges. Instead of working from plaster models or copying European models in the studio, students were sent out into the streets and the countryside to take their inspiration from Mexican reality. In addition to their practical training, the budding artists also took classes in the academic subjects of mathematics, Spanish, French, history and art history. Since most of

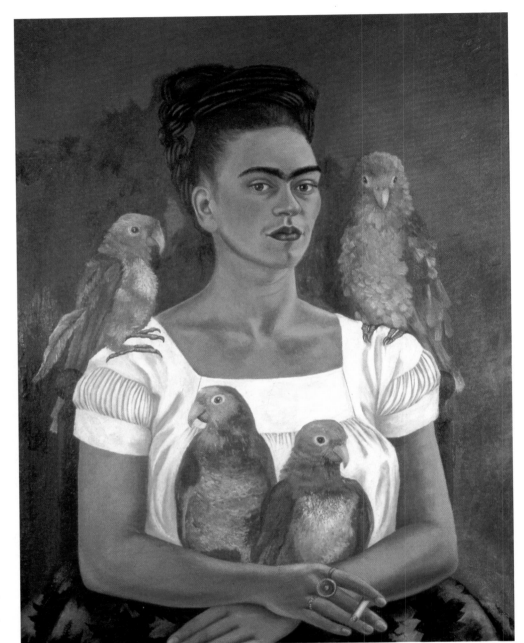

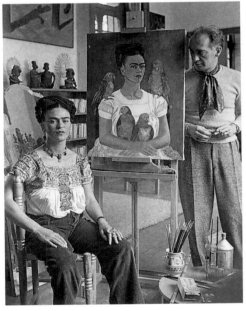

Frida Kahlo and her lover, Nickolas Muray, in front of the painting *Me and My Parrots,* around 1939/40
After their affair, Muray wrote to Frida Kahlo: "I knew NY only filled the bill as a temporary substitute and I hope you found your haven intact on your return. Of the three of us there was only two of you. I always felt that. Your tears told me that when you heard his voice.
The one of me is eternally grateful for the happiness that the half of you so generously gave."

Me and My Parrots, 1941
This portrait arose during her love affair with Nickolas Muray. Muray was one of the most successful portrait photographers in the USA. He helped Frida Kahlo, whom he had already met in Mexico, with the preparations for her exhibition in Julien Levy's gallery in New York in 1938. The four parrots are taken from Hindu imagery, where they serve as the bearers of the love god Kama. As erotic symbols, they point to the artist's relationship with Muray.

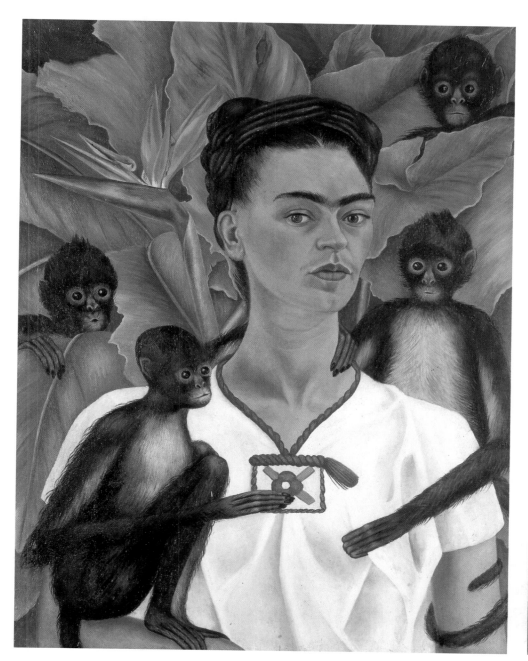

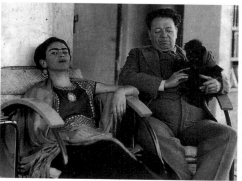

Self-portrait with Monkeys, 1943
Rivera saw Frida Kahlo as "the personification
of all national glory". He was thereby refer-
ring both to her outward appearance and her
artistic oeuvre. She painted the flora and fauna
of Mexico, depicted cacti, plants of the prim-
eval forest, volcanic rock, parrots, deer, mon-
keys and Itzcuintli dogs – animals which she
also kept as pets and which appear in her
pictures as symbols or companions of her
solitude.

Frida Kahlo and Diego Rivera with one of
their many pets, the spider monkey Caimito
de Guayabal.

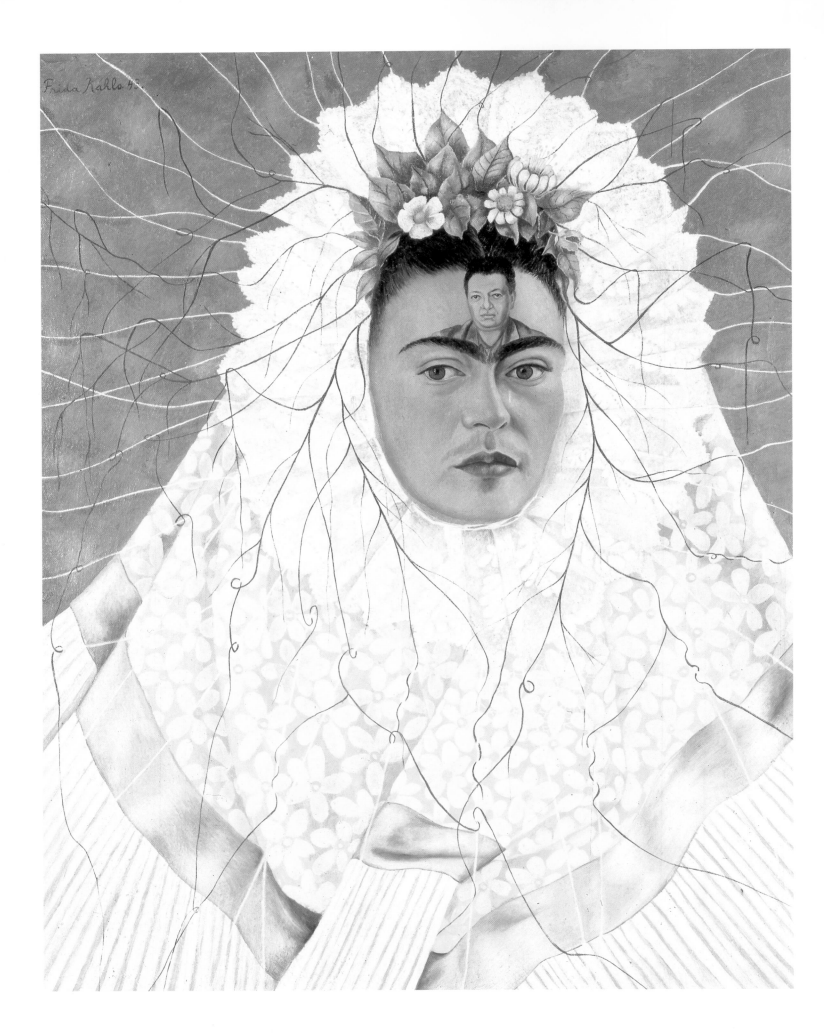

the students came from families on low incomes, tuition and materials were free.

Frida Kahlo's unorthodox teaching methods surprised many of her pupils. She insisted that everyone use the familiar *tu* form of address right from the start and placed great emphasis on a comradely relationship. She did not patronize her students, but encouraged self-development and self-criticism. She sought to teach them a few technical principles and the necessary self-discipline, and commented on their works, but never intruded directly upon the creative process. "The only help she gave us was to stimulate us, nothing more. She did not say even half a word about how we should paint, or anything about style, as the maestro Diego did. [...] What she taught us, fundamentally, was love of the people, and a taste for popular art", her students recalled. "Muchachos", she would announce, "locked up here in school we can't do anything. Let's go out into the street. Let's go and paint the life in the street."[32]

After a few months, Frida Kahlo was forced by her poor health to teach from her Coyoacán home. Constant pain in her back and right foot made it impossible for her to travel into the school, not least since she had been ordered to rest completely. She had to wear a steel corset, which reappears in her self-portrait of 1944, *The Broken Column* (ill. p. 69). The straps of the corset seem to be all that is holding the artist's rent body together and upright. An Ionic column, broken in several pieces, takes the place of her damaged spine. The yawning cleft in her flesh is taken up in the furrows scarring the bleak, fissured landscape behind, which thereby becomes a symbol both of her pain and her loneliness. Even more powerful symbols of her pain, however, are the nails sticking into her face and body, recalling images of the martyrdom of St. Sebastian, pierced by arrows. Another reference to Christian iconography appears in the white cloth draped around her hips, echoing Christ's winding sheet. Indeed, Frida Kahlo frequently cites from the portrayals of Christ, the Virgin and saints which decorate almost every church and many household altars throughout Mexico. She employs the Crown of Thorns, the arrow, the knife, the heart and open wounds to give particularly dramatic expression to her pain and suffering. Such elements of Christian iconography, however, should no more be taken as a manifestation of her Catholic faith than her references to religious ex votos. Frida Kahlo shared the anticlerical stance of Mexican intellectuals and post-revolutionary Mexican politics, according to which churches were being shut in order to destroy the previous overly-powerful influence of the clergy. She saw the religious pictures from which she borrowed as expressions of fundamental popular beliefs, which did not depend for their significance on the Catholic church. Hence she could freely employ Christian imagery for her own purposes, and present her own self in the role of martyr.

Frida Kahlo also negotiated commissions for several of the students studying mural painting – a compulsory course at the school – under Diego Rivera. One such commission was a decorative scheme

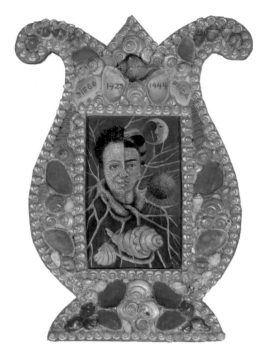

Diego and Frida 1929–1944 (I)
or *Double Portrait, Diego and I* (I), 1944
Frida Kahlo painted this double portrait for Diego Rivera's 58th birthday. It expresses the fact that her husband not only dominated her thoughts, but was virtually one with the artist herself. In the dualistic relationship between husband and wife, reiterated in the sun and moon, the Kahlo-Rivera couple are shown to belong together, whereby the scallop and the snail symbolize their love union.

Self-portrait as a Tehuana
or *Diego in My Thoughts*
or *Thinking of Diego,* 1943
The portrait of Rivera on her brow indicates Frida Kahlo's obsessive love for the fresco painter: he is constantly in her thoughts. She is wearing the Tehuana costume which Rivera loved so much. It comes from a region in southwest Mexico in which matriarchal traditions survive even today, and whose economic structure reflects the dominant role of women. The roots of the leaves which she wears in her hair suggest the pattern of a spider's web in which she seeks to trap her prey – Diego.

for the *pulquería* "La Rosita" in Coyoacán, one of the many bars serving exclusively the popular *pulque* drink. The mural was carried out in oils under the direction of the Kahlo-Riveras. A big party was held to celebrate its inauguration, which attracted a lot of coverage in the press. This was the cue for numerous further commissions for *pulquería* decorations. Frida Kahlo also helped to find exhibition venues for her pupils' paintings. Of the originally somewhat larger group of young people who came to Coyoacán for their lessons, only four ultimately remained faithful: Arturo Estrada, Arturo García Bustos, Guillermo Monroy and Fanny Rabel, who became known as "Los Fridos". They were frequent guests in the Blue House even in later years.

In September 1946 the fresco and panel painter José Clemente Orozco received the National Prize for Art and Science at the annual art exhibition in the Palacio de Bellas Artes. There were four additional prizes for painting, which were awarded to Dr. Atl, Julio Castellanos, Francisco Goitia and Frida Kahlo, for her work *Moses* (ill. p. 74). Although still recovering from an operation on her spine earlier in June, the artist attended the award ceremony and proudly accepted her prize.

She had been advised to have her spine strengthened by a specialist in New York. Shortly after the operation, she wrote from the United States to her old friend Alejandro Gómez Arias: "So the big operation is now behind me. [...] I have two huge scars on my back in this shape."[33] The drawing (ill. p. 71 right) seems to have served as the basis for the self-portrait *Tree of Hope, Keep Firm* (ill. p. 71). Frida Kahlo executed this self-portrait for her patron, the engineer Eduardo Morillo Safa, to whom she wrote: "I have almost finished your first painting, which is of course nothing but the result of the damned operation: I am sitting – on the edge of an abyss – with my leather corset in one hand. In the background, I am lying on a hospital trolley – facing away at the landscape – with part of my back uncovered, so you can see the scars from the incisions which those surgeon sons of bitches landed me with."[34] The bared, violated, weakened body on the left contrasts with the forceful, upright figure of Frida Kahlo on the right, gazing purposefully into the future. In the message "Tree of hope, keep firm" written in red on her flag, she seems to be giving herself courage. The split in her personality, the duality of her being, is reflected in the division of the picture into two halves, one day and one night. The maimed body is assigned to the sun, which in Aztec mythology is fed by sacrificial human blood. Two gaping wounds in her back are echoed in the fissures in the landscape behind. The strong, optimistic Frida, on the other hand, is assigned to the moon, the symbol of womanhood.

This dualistic principle, which characterizes many of her works, can be traced back to the mythology of ancient Mexico, from which the artist also drew inspiration. It became the expression of her philosophy of nature and life, her view of the world. This dualism is based on the Aztec concept of permanent war raging between the

The Broken Column, corset, around 1944
Towards the end of her life Frida Kahlo had to wear various orthopaedic corsets of different materials, some of which she painted. She decorated one plaster cast with a hammer and sickle, for example, and another with a foetus. The above corset shows a picture of her own broken spinal column.

The Broken Column, 1944
In 1944, when Frida Kahlo painted this self-portrait, her health had deteriorated to the point where she had to wear a steel corset. An Ionic column, broken in several places, takes the place of her damaged spine. The cleft in her body and the furrows in the bleak, fissured landscape become a symbol of the artist's pain and loneliness.

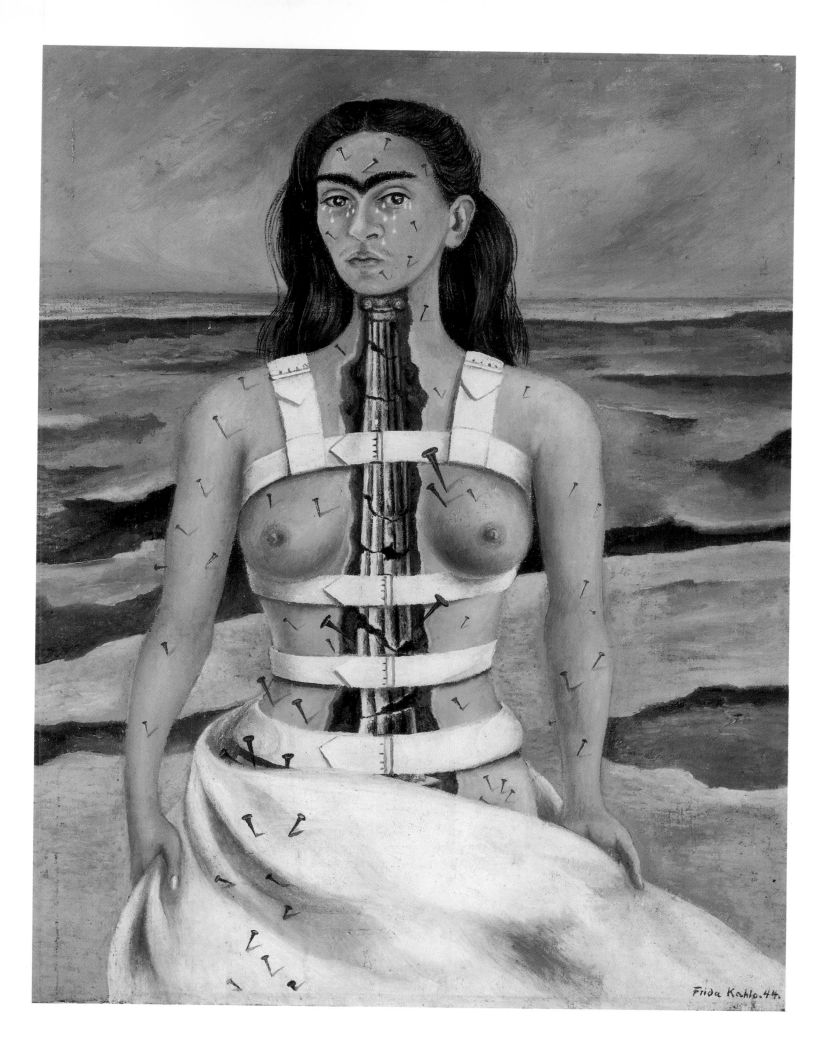

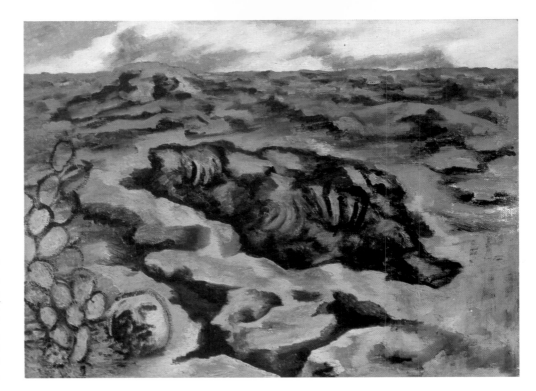

Landscape, around 1946/47
The desolate and fissured landscape which frequently provides the background for Frida Kahlo's work is here made the centrepiece of the composition. It symbolizes the artist's own body, scarred and wounded by her operations. The presence of a skeleton is suggested in the large hollow in the middle of the picture. The atmosphere is lifeless and bleak.

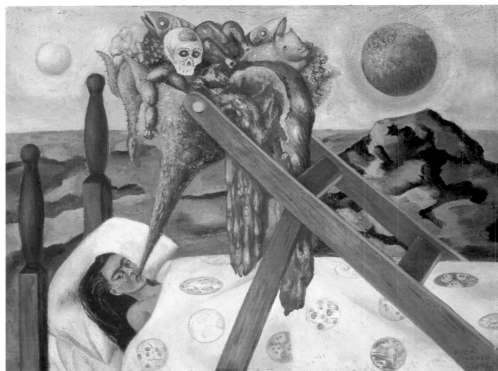

Fantasy (I), 1944
On the back of this drawing, Frida Kahlo glued the following words: "Surrealism is the magical surprise of finding a lion in a wardrobe where you were sure of finding shirts." Her drawing is symbolic rather than Surrealist, however, and shows the fissured, parched landscape found in many of her works.

Without Hope, 1945
Frida Kahlo added the following explanation on the back of the picture: "Not the least hope remains to me ... Everything moves in time with what the belly contains". As a result of a lack of appetite, Frida Kahlo grew very thin and was prescribed a fattening diet. The artist was clearly nauseated by this "forced feeding".

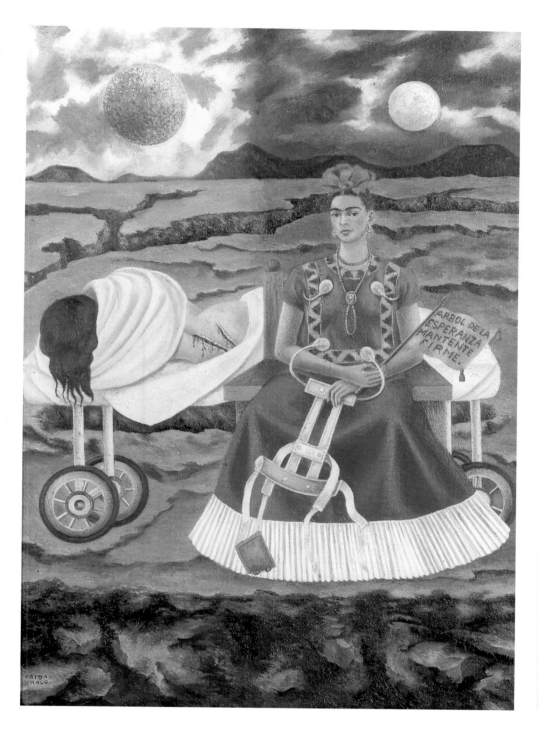

aminoró el alarido y con
ayuda de pastillamina he
sobrevivido más o menos bien.
Tengo dos cicatrizotas en the
espaldilla en this forma

procedieron al arranquien del
cacho de pelvis para injertar-
lo en la columnata, que
es donde la cicatriz me quedó
menos horripilante y más
derechita. Cinco vertebri-
llas eran las dañadas y
ahora van a quedar cual
riflamen. Nada más que

Tree of Hope, Keep Firm, 1946
Frida Kahlo painted this self-portrait for her
patron, the engineer Eduardo Morillo Safa, af-
ter an operation in New York. She wrote to
him about the picture and about the scars
"which those surgeon sons of bitches landed
me with". In the message "Tree of hope, keep
firm", which is written on her flag, she seems
to be giving herself courage. The phrase is ta-
ken from one of her favourite songs.

Letter from Frida Kahlo to Alejandro Gómez
Arias, 30 June 1946
In a letter from New York, she described the
operation on her spine to her friend: "So the
big operation is now behind me... I've got two
huge scars on my back in this shape."

Frida Kahlo, photographed around 1939 with her faun Granizo, who later served as the model for the young stag in *The Wounded Deer* (ill. p. 73).

white god Huitzilopochtli, who is the sun god, the personification of day, summer, the south and fire, and his opponent Tezcatlipoca, the black god of the set sun and the personification of night and the firmament, winter, the north and water. The battle between these two forces ensures that the world remains in equilibrium. The principle of duality in unity is present in particular in those self-portraits where Frida Kahlo divides the pictorial ground into two halves, one light and one dark, one day and one night. Sun and moon, representing the male and the female principle, are made to appear simultaneously. The bipartite nature of the universe is even extended to her own self, whom she presents as two, split personalities.

The belief that life and death are mutually contingent is similarly a facet of the notion of equilibrium derived from American Indian mythology. In many of Frida Kahlo's works, plants are used to symbolize life as the eternal cycle of nature. One part of this life cycle, represented in Aztec mythology by the goddess Coatlicue, is death. Coatlicue stands for the beginning and end of all things, contains life and death, gives and takes at the same time. In the ancient Mexican sense, therefore, death simultaneously means rebirth and life. In the self-portrait *Thinking about Death* (ill. p. 62), for example, death is presented against a background of thorny branches – a symbol taken from pre-Hispanic mythology through which the artist points to the rebirth that follows death. To understand the attitude to death which prevails in Mexico, one must be familiar with the philosophy of life inherited from its pre-Columbian past. It is the philosophy which underlies the satirical prints of José Guadalupe Posada, for example, in which death is caricatured (cf. ills. p. 24). It is expressed most clearly in the customs and beliefs surrounding the Day of the Dead on November 2nd, when the feast tables prepared for dead relatives will be sure to include the candy skulls – *cavaleras* – which, rather like our own chocolate Father Christmases and Easter eggs, are given and eaten by children and adults alike. In contrast to its All Souls' Day variants in Europe, the Mexican Day of the Dead is not a day of mourning, but a day of celebration which in many places is spent picnicking with the dead in the cemetery. It is simultaneously an expression of gratitude for life and an acknowledgement of the life cycle. For death itself is seen more in terms of a process, a path or transition to a life of another kind.

One picture by Frida Kahlo in which ancient Mexican mythology emerges particularly clearly is *The Love Embrace of the Universe, the Earth (Mexico), Myself, Diego and Señor Xólotl* (ill. p. 77). Here as nowhere else she illustrates the dualistic principle which has its parallels in the yin and yang of Chinese philosophy. Day and night permeate each other. Luminous spirituality and lightless matter, sun and moon, form the nucleus of the universe, which enfolds the dark earth in its mighty arms. The earth goddess Cihuacoatl, the life-giving mother from whose womb, according to mythology, all flora springs, holds the artist in her fertile lap not unlike the Indian wet-nurse in *My Nurse and I* (ill. p. 47). Frida herself appears as a smaller

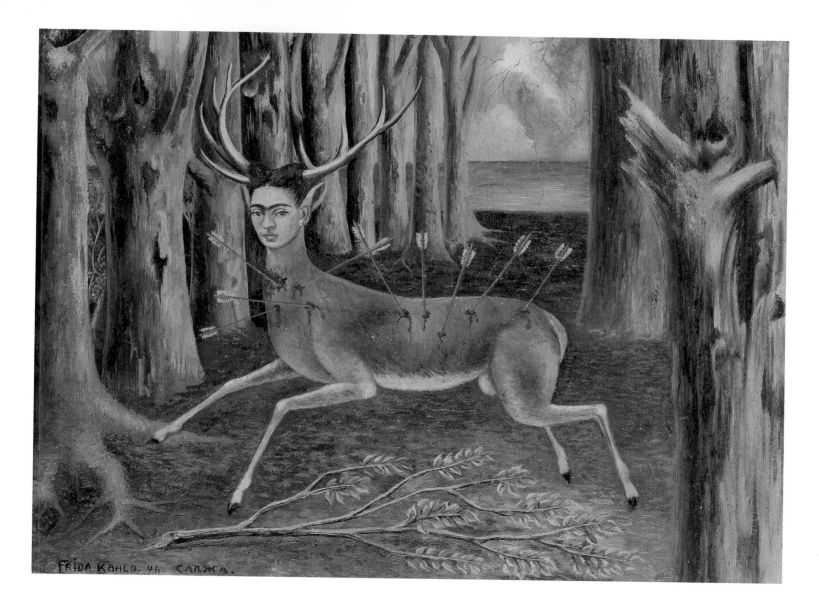

representation of the earth mother; but whereas the breast of the latter drips life-giving milk, Frida's breast sprays a fountain of blood. Her bitterly-felt inability to bear a child led her to adopt a maternal role towards Diego Rivera. Like a Madonna, she holds him in her arms, his figure in turn reminiscent of a Buddha. As in the self-portrait *Diego and I* (ill. p. 78), he possesses a third eye, the eye of wisdom, while the flames which he holds in his hand stand for purification, renewal and rebirth.

In an essay written to coincide with an exhibition of her husband's work in 1949, she described him in terms which correspond closely to his portrait here: "With his Asiatic-type head, upon which grows dark hair so thin and fine that it seems to float in the air, Diego is an immense baby with an amiable face and a slightly sad glance. His bulging, dark, extremely intelligent, large eyes are rarely still [...] Between those eyes, so distant one from the other, one divines the invisible eye of Oriental wisdom, and only very seldom does an ironic and tender smile, the flower of his image, disappear from his Buddha-like mouth with its fleshy lips. Seeing him nude, one immediately thinks of a boy-frog standing on his hind legs. His

The Wounded Deer or *The Little Deer* or *I am a Poor Little Deer,* 1946
In this image of a young stag fatally wounded by arrows, the artist expresses the disappointment which followed the operation on her spine in New York in 1946, and which she had optimistically hoped would cure her of her pain. Back in Mexico, however, she continued to suffer both physical pain and deep depressions.

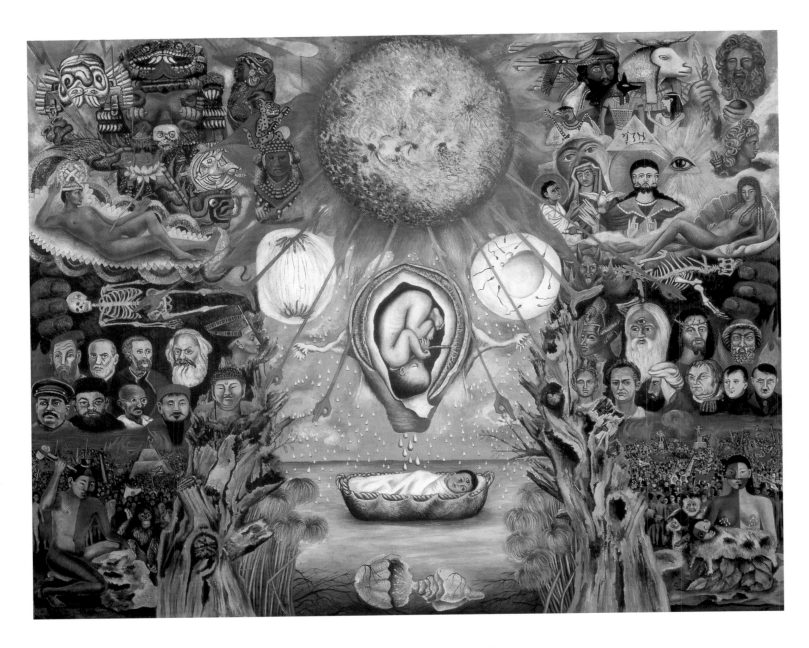

Moses or ***Nucleus of Creation,*** 1945
For this work Frida Kahlo was awarded second prize at the annual art
exhibition in the Palacio de Bellas Artes. The inspiration for the
painting was provided by Sigmund Freud's book, "Moses the Man and
Monotheistic Religion", which one of her patrons, José Domingo
Lavin, had lent her. She was fascinated by the book and painted the
picture within three months. The central figure of the abandoned
baby Moses closely resembles Diego Rivera, and wears – like Diego in
other pictures – the third eye of wisdom on his forehead.

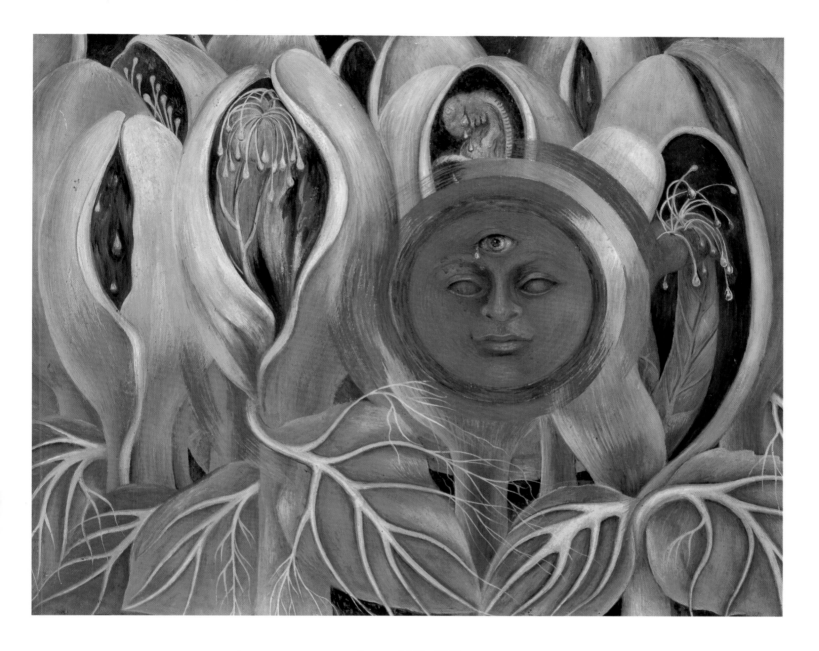

Sun and Life, 1947
The amorphous plant forms are symbols of the female and male genitals. The life-giving sun appears in the centre. The weeping foetus in one of the plants and the teardrop flower pistils in others signify Frida Kahlo's sadness at her inability to bear a child.

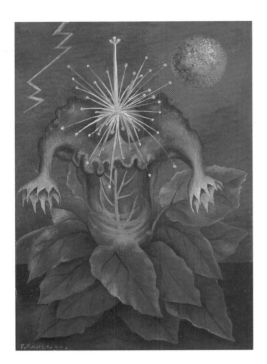

Flower of Life, 1943
Frida Kahlo makes her own powerful sexuality the subject of this picture. She transforms an exotic plant into male and female sex organs. The life-giving sun shines down on the phallus and a foetus emerging from the mother's womb. For the artist, the flower was a symbol of sexuality and feelings.

The Love Embrace of the Universe, the Earth (Mexico), Myself, Diego and Señor Xólotl, 1949
Frida Kahlo frequently adopted a maternal role towards her husband and emphasized that women in general, and "amongst them – I – always want most of all to hold him in their arms like a new-born baby". The picture contains many elements derived from ancient Mexican mythology: day and night, sun and moon, the earth goddess Cihuacoatl. The Itzcuintli dog Señor Xólotl is also more than simply one of the artist's favourite pets; it simultaneously represents Xólotl, a being in the form of a dog who guards the underworld.

skin is greenish white like that of an aquatic animal. Only his hands and face are darker, burnt by the sun. His childlike shoulders, narrow and round, flow without angles into feminine arms that end in wonderful hands, small and finely-drawn, which, sensitive and subtle, communicate like antennae with the whole universe."[35]

She emphasized that women in general, and "amongst them – I – always want most of all to hold him in their arms like a new-born baby". This mother-child relationship is illustrated in Rivera's own mural, *Sunday Afternoon Dream in Alameda Park* (ill. p. 56 above). Frida Kahlo, holding a yin-yang symbol in her left hand, stands behind the figure of Diego as a boy, her right hand placed protectively on his shoulder.

For the artist, however, her husband was far more to her than simply her unborn child:

> *"Diego. beginning*
> *Diego. constructor*
> *Diego. my child*
> *Diego. my bridegroom*
> *Diego. painter*
> *Diego. my lover*
> *Diego. 'my husband'*
> *Diego. my friend*
> *Diego. my father*
> *Diego. my mother*
> *Diego. my son*
> *Diego. I*
> *Diego. universe*
> *diversity in unity*

Why do I call him My Diego? He never was nor ever will be mine. He belongs to himself"[36], she wrote in her diary.

That her husband not only dominated her thoughts, as shown in the self-portrait *Diego in My Thoughts* (ill. p. 66), but was virtually one with the artist herself, is expressed in the double portrait *Diego and Frida 1929–1944* (ill. p. 67) of 1944. She painted it for Rivera's 58th birthday. In the dualistic relationship between husband and wife, reiterated in the sun and moon, the Kahlo-Rivera couple are shown to belong together, whereby the scallop and the snail symbolize their love.

In *The Love Embrace of the Universe,* this love is guarded by an Itzcuintli dog, Señor Xólotl, who is curled up at the couple's feet. The dog is not just a pet of the same name from the artist's household, but simultaneously represents Xólotl, a being in the form of a dog who guards the realm of the dead in ancient Mexican mythology. The dead are carried on his back – like the sun every evening – across the ninefold river into the underworld, so that they can then be resurrected. With the dog, therefore, the dualistic principle of pre-Hispanic mythology is complete – life and death are incorporated equally into the artist's harmonious conception of the world.

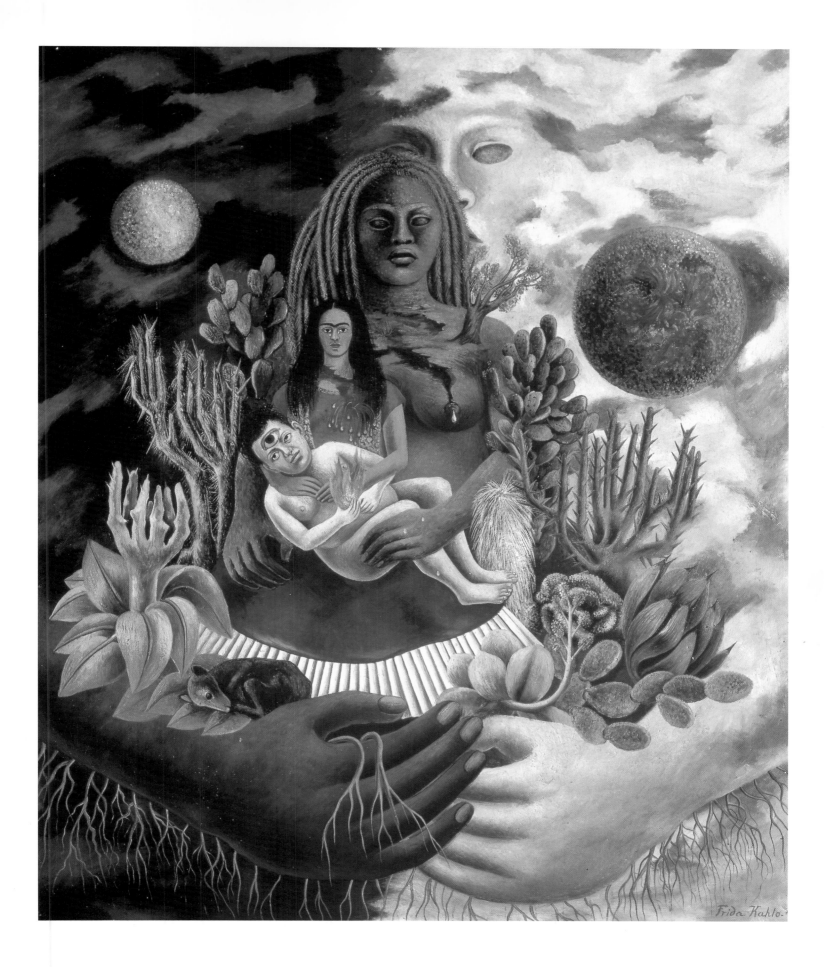

"I hope the exit is joyful..."

The end of the 1940s saw a serious deterioration in Frida Kahlo's health. In 1950 she spent nine months in the ABC hospital in Mexico City (ill. p. 91). Due to poor circulation in her right leg, four of her toes suddenly turned black, and amputation was considered. She was also having renewed problems with her back. After a second operation on her spine, she developed an infection which eventually made it necessary to operate again. Not until November, after the sixth of a total of seven operations in the course of the year, was she well enough to resume painting for four or five hours a day. A special easel was mounted on her bed so that she could work lying on her back.

One of the results was the *Self-portrait with the Portrait of Dr. Farill* (ill. p. 80), a dedication to the surgeon who had performed her operations and looked after her during her stay in the ABC hospital. "I was sick for a year: 1950–1951. Seven operations on my spine", she wrote in her diary. "Doctor Farill saved me. He gave me back my joy in life. I am still in a wheelchair and I don't know how soon I will be able to walk again. I have a plaster corset, which, in spite of being a frightful bore, makes my spine more bearable. I feel no pain, just a great weariness...and as is natural, often desperation. Indescribable desperation. Nevertheless, I want to live. I have already begun the little painting that I am going to give to Doctor Farill and that I am doing with all my affection for him."[37] This self-portrait, too, may be understood as a thanksgiving *retablo:* it represents a sort of votive offering to the doctor who saved the artist from her plight and here appears in the place of a saint.

Frida Kahlo was now only able to walk very short distances at a time, and then only with the aid of a stick or crutches. She was frequently obliged to use a wheelchair. In consequence, the majority of her time was spent at home. Her closest relationships were now almost exclusively with women; solely with Rivera was she as intimate as before. She usually painted in bed, working in her studio or the garden only when she felt strong enough. In these last years of her life, she produced few self-portraits, painting almost exclusively still lifes. But whereas her work up to 1951 had been executed with extreme technical precision, in what might almost be called miniaturist style, the poor state of her health now began to affect the

Frida and Diego, around 1954

Diego and I, 1949
Frida Kahlo painted this self-portrait during the period when Diego Rivera was having an affair with film star María Félix, a relationship which provoked a public scandal. Wretched and weeping, she looks mournfully out at the viewer. Her long hair has wrapped itself around her neck and threatens to choke her. Her hair again becomes the vehicle through which she expresses her emotional anguish. Frida Kahlo painted the portrait for her married friends Florence Arquin and Sam Williams.

Self-portrait with the Portrait of Dr. Farill or *Self-portrait with Dr. Juan Farill,* 1951
This self-portrait, in which she appears in a wheelchair in front of a portrait of her doctor on an easel, forms a sort of votive offering to the doctor who rescued the artist from disaster and here appears in the place of a saint. The patient is painting with her own blood and using her heart as a palette.

steadiness of her hand. After 1951 she was in such severe pain that she was no longer able to work without taking painkillers. Her increasingly strong medication must be seen as the reason for the looser, hastier, almost careless brushwork, thicker application of paint and less precise execution of detail which now began to characterize her painting. In 1954, the year of her death, she was at times unable to paint at all, as we learn from a remark made by her friend, the writer Carlos Pellicer, whom Rivera later entrusted with the conversion of the Blue House into the Frida Kahlo Museum. "There [in her studio], in the last few days [before her death], she tried to paint me a small landscape with self-portrait. But it never got further than a few 'dabs'."[38]

Her health also prevented the artist from expressing herself politically in her art. This had been one of her concerns ever since rejoining the Mexican Communist Party in 1948, and since 1951 in particular. "I am very worried about my painting", she wrote in her diary that year, "above all, because I want to turn it into something useful; until now I have managed simply an honest expression of my own self, but one which is unfortunately a long way from serving the Party. I must struggle with all my strength to ensure that the little positive that my health allows me to do also benefits the Revolution, the only real reason to live."[39]

This political ambition was to permeate even the still-lifes of her last years. Thus the *Still life with "Long Live Life and Dr. Farill"*, which must have been painted between 1951 and 1954 and was also a present for the doctor to whom she owed so much, contains details

which must be read in a political light. Against a sky divided into day and night, characterized respectively by sun and moon, a selection of exotic fruits are portrayed on a blood-red ground. Sticking into the flesh of a slice of watermelon is the red, white and green Mexican flag, symbol of the artist's nationalism. A white dove of peace appears in front of the fruits – a frequent motif in works of this period. In a landscape painted for the 1952 International Peace Congress, the same dove sits on the tree of peace guarding the ripening fruits, again accompanied by both sun and moon. Under the mighty force of the peace movement, the atomic clouds in the background are unable to mushroom into their full size. Frida Kahlo had helped to collect a list of signatures supporting the Peace Congress, which was protesting in particular against nuclear testing by what were seen as the imperialist great powers.

In his mural *The Nightmare of War and the Dream of Peace* (ill. p. 84) of that same year, Rivera thus shows his wife as a political activist. The peace symbol of the dove appears here, too, held in the hands of the Communist leaders Stalin and Mao. The demonstration of 2 July 1954 protesting against the overthrow by the CIA of the democratic government of Guatemalan president Jacobo Arbenz Guzmán was Frida Kahlo's last public appearance. She carried a banner bearing a dove and a peace slogan (ill. p. 93 right).

Her stated aim to introduce a political dimension into her work, in order to "serve the Party" and "benefit the Revolution", only becomes explicit in her last productive phase, and in particular in three paintings with overtly Communist themes: *Marxism Will Give Health to the Sick* (ill. p. 85), *Frida and Stalin* (ill. p. 87) and an unfinished portrait of Stalin. All three works are undated, but the technique and superficial execution of details clearly assign them to the last years of the artist's life. In *Marxism Will Give Health to the Sick,* the artist embraces the utopian belief that political conviction can free her – and with her, the whole of mankind – from pain and suffering. Wearing her leather corset, she appears one last time against a divided background, one half representing the peaceful part of the earth, the other the part threatened with destruction. Above the clear blue rivers running through the left-hand landscape, the dove of peace rises from the red Soviet and Chinese continent into the heavens. In the gloomy night sky on the right, however, the American eagle, with the head of Uncle Sam and a bomb as its body, hovers over a landscape threatened by an atomic mushroom cloud and streaming with blood. Rescue from this calamity is nevertheless in sight. Here again the artist employs the narrative style of votive pictures, whereby Karl Marx takes the place of the saint whose intervention will save the world from impending doom and bring peace. Meanwhile, the sick artist is undergoing a miraculous cure. She is gently supported by huge hands, symbols of Marxism, one of them bearing the eye of wisdom, allowing her to throw away her crutches. "For the first time, I am not crying anymore"[40], she said of this picture.

Frida and Stalin must also be seen as a sort of votive picture.

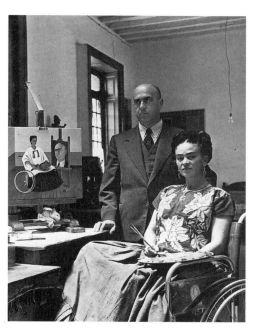

Frida Kahlo and Dr. Juan Farill in front of the *Self-portrait with the Portrait of Dr. Farill.* Like Frida Kahlo, Dr. Farill was also lame, and could only walk with the aid of crutches. He was an understanding friend and the artist was very fond of him.

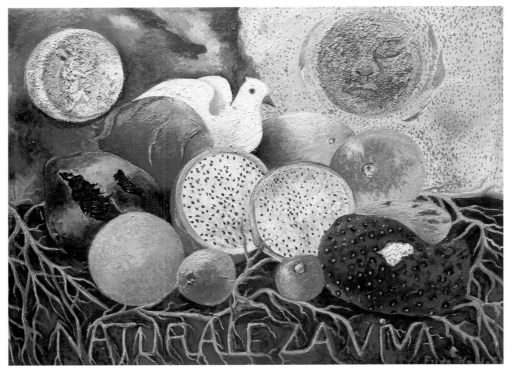

Living Nature, 1952
This late painting contains many elements drawn from other works by the artist. The sky is divided into day and night, and both sun and moon are present. The fruits are linked by roots, which form the words "Naturaleza viva" (living nature), whereby the artist rejects the "dead" connotations of the "Naturaleza muerta" (the Spanish for still life or ***nature morte***).

Still life with Flag, around 1952–54

Like the *Self-portrait with the Portrait of Dr. Farill* (ill. p. 80), in which the doctor plays the part of the Saviour, Stalin here assumes the role of saint. The artist thereby reveals her almost religious faith in Communism.

But while her painting now deliberately took on a more blatantly propagandist function, Frida Kahlo had been stating her political position in a much subtler manner since her earliest years as a painter. She subscribed as a Mexican artist to the new set of values which followed the Revolution and supported the search for a national identity. Her pictures clearly detached themselves from neo-colonial North American and European influences. This political emphasis upon an independent Mexican culture, with its pre-Colum-

Fruit of Life, 1953
In the early fifties Frida Kahlo painted chiefly still lifes. During this period she was in such pain that she was unable to leave the house or even, at times, her bed. Her still lifes usually show the fruits from her garden or the local market which stood on her bedside table. She politicized her pictures by adding flags, inscriptions and peace doves.

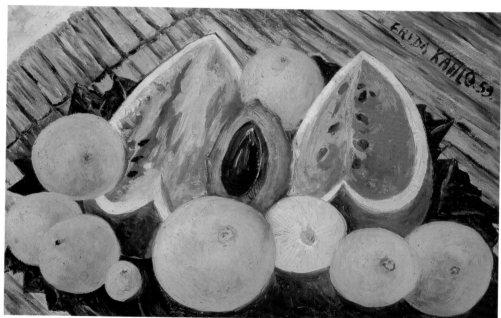

Still life with Watermelons, 1953

bian and Hispanic roots, is reflected throughout her oeuvre. Her art thereby carries an inherent political message, even though the artist herself said: "My painting is not revolutionary. Why should I kid myself that it is militant?"[41]

Her identification with the Mexican nation and its cultural roots cannot be seen merely as a portrayal of her private surroundings and personal problems. It is clearly an intellectual stance influenced by the political and cultural developments which followed the Mexican Revolution.

In spring 1953 the photographer Lola Alvarez Bravo, a friend of Frida Kahlo's who was fully aware of her significance as a Mexican artist, organized the first solo exhibition of her work to be held in

Mexico. "I realized that Frida's death was quite near", she explained. "I think that honors should be given to people while they are still alive to enjoy them, not when they are dead."[42]

On the evening of the opening of the exhibition, the artist's health was so poor that the doctors forbade her to get up. Not prepared to miss the vernissage on any account, however, she had her bed sent along ahead and herself taken to the gallery by ambulance. Bolstered by painkillers, she took part in the celebrations from her bed, drinking and singing with the crowd of visitors. She was just as dazed by the success of the exhibition as the gallery-owner herself, who even received inquiries about the artist from abroad. The success of the show was nevertheless overshadowed by the illness of the artist.

The pain in her right leg had now become intolerable, and in August 1953 the doctors decided to amputate it below the knee. Although the artificial leg which she subsequently wore relieved her pain, and even allowed her to walk again, the operation sent Frida Kahlo into a deep depression. Describing her condition following the amputation, Rivera stated that "she had lost her will to live".[43]

Five months later, however, she had learned to walk short distances with the artificial leg. She even appeared in public again, albeit very rarely. Her moods varied from the euphoric proclamation, "Why do I need feet when I have wings to fly?" (ill. p. 90), to the diary entry of February 1954: "They amputated my leg six months ago, they have given me centuries of torture and at moments I almost lost my reason. I keep on wanting to kill myself. Diego is the one who holds me back because of my vanity in thinking that he would miss me. He has told me so and I believe him. But never in my life have I suffered more. I will wait a little while..."[44]

Seriously ill with pneumonia, Frida Kahlo died during the night of 12–13 July 1954, seven days after her 47th birthday. Pulmonary embolism was diagnosed as the cause of her death. The evening before, "because I feel I am going to leave you very soon"[45], she had given her husband a present for their silver wedding anniversary on 21 August. The suicidal thoughts recorded in the artist's diary suggest that she may have taken her own life. Her last entry reads: "I hope the exit is joyful...and I hope never to come back...Frida."[46]

On the afternoon of 13 July, her coffin was placed in the entrance hall of the Palacio de Bellas Artes, attended by a guard of honour. Like so many of the public appearances which she made during her lifetime, even this very last one was to cause a stir. With Rivera's permission, during the vigil some of her political friends covered the coffin with a red flag emblazoned with a hammer and sickle framed by a white star. This provoked a great public outcry, as a result of which Andrés Iduarte, a former schoolfriend of Frida Kahlo's, had to resign from his post as Director of the Instituto Nacional de Bellas Artes. The guard of honour was maintained for one day and one night. By the afternoon of 14 July, more than six hundred people had come to pay their last respects. Followed by a pro-

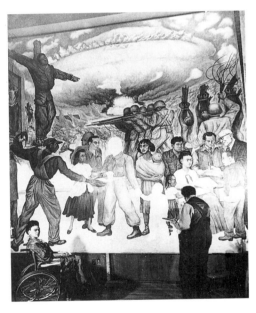

Frida Kahlo in a wheelchair and Diego Rivera in front of his mural *The Nightmare of War and the Dream of Peace,* 1951/52
In 1952 Frida Kahlo helped collect a list of signatures supporting the International Peace Congress then being held, which was protesting in particular against nuclear testing by what were seen as the imperialist great powers. In this mural of the same year Rivera portrays his wife as a political activist. In the photograph, Rivera is in the middle of painting Fridas figure.

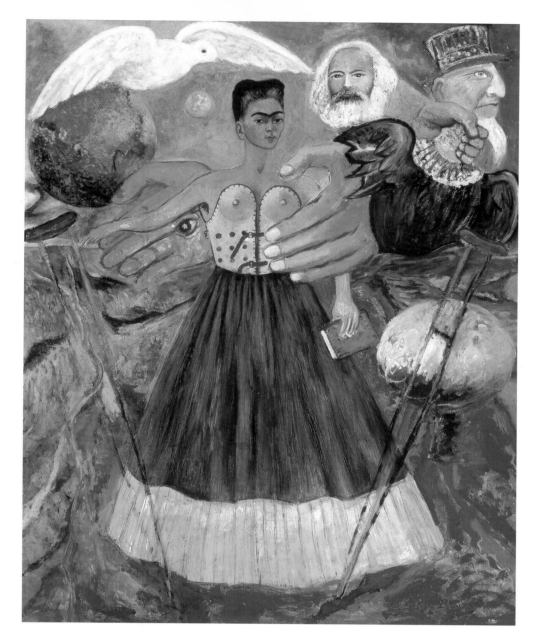

Marxism Will Give Health to the Sick,
around 1954
In this portrait, the artist embraces the utopian belief that political conviction can free her – and with her, the whole of mankind – from pain and suffering. Supported by her ideology, she can throw away her crutches. "For the first time I'm not crying anymore", she said of this picture.

cession made up of some five hundred people, Frida Kahlo's body was then carried through the town to the crematorium. After several speeches, and to the accompaniment of songs, she was cremated according to her own wishes.

Her ashes are today housed in a pre-Columbian vessel in the Blue House. One year after her death, Diego Rivera bequeathed the house to the Mexican nation as a museum (ills. p. 88/89). Preserved in its almost original state, it contains, in addition to the works she left behind, items of popular art, a collection of *retablos* and paintings, the artist's Tehuana dresses and jewellery, her painting utensils, letters and books, as well as her diary – undoubtedly her most intimate testament. On 12 July 1958 the Blue House was opened as the Museo Frida Kahlo, dedicated to the artist whose remarkable personality lives on within its walls.

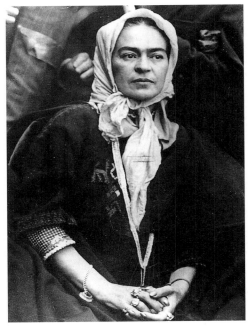

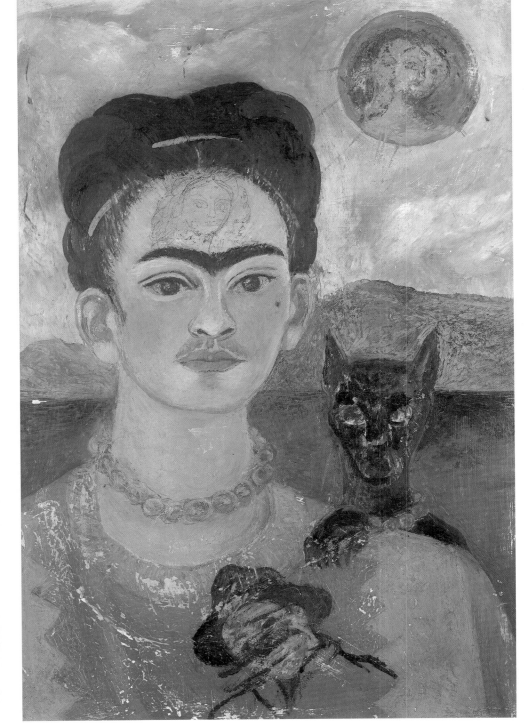

Frida Kahlo, 2 July 1954
Frida Kahlo took part in the demonstration against the overthrow by the CIA of the democratic government of Guatemalan president Jacobo Arbenz Guzmán in her wheelchair, despite the fact that she was suffering from pneumonia and her doctors had advised against it. She died eleven days later.

Self-portrait with a Portrait of Diego on the Breast and María between the Eyebrows, 1953/54
After 1951, Frida Kahlo was in such severe pain that she was no longer able to work without taking painkillers. Her increasingly strong medication may be seen as the reason for the looser, hastier, almost careless brushwork, thicker application of paint and less precise execution of detail which characterize her late works.

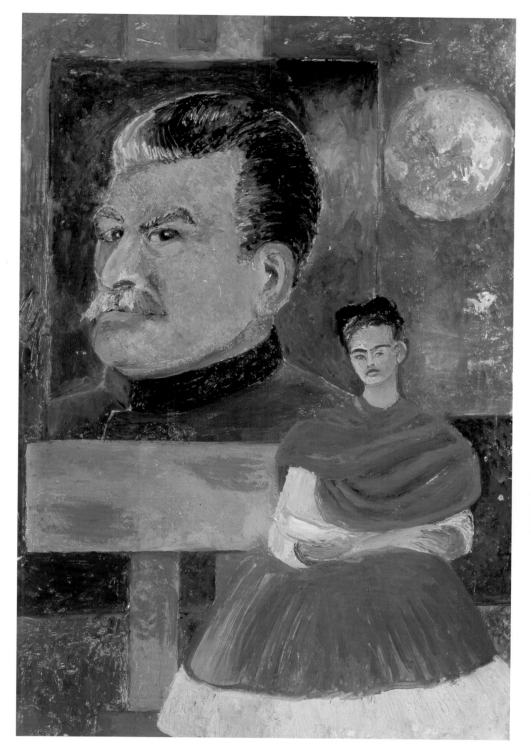

Self-portrait with Stalin or
Frida and Stalin, around 1954
The votive nature of this picture may be compared with the ***Self-portrait with the Portrait of Dr. Farill*** (ill. p. 80), in which the doctor plays the part of the Saviour. Here it is Stalin who assumes the role of saint. The artist thereby reveals her almost religious faith in Communism.

Frida Kahlo, around 1952/53
Frida Kahlo is sitting in front of the pyramid bearing her collection of pre-Hispanic sculpture in the garden of the Blue House. The photograph was taken by her nephew, Antonio Kahlo.

Inner courtyard of the Blue House in Coyo-
acán. Frida Kahlo was born in this house,
spent the large part of her life here and died
here on 13 July 1954.

The dining room looks onto the inner
courtyard. The inscription on the wall reads:
"Frida and Diego lived in this house
1929–1954".

OPPOSITE PAGE:
Frida Kahlo's studio was designed and built
by Rivera in 1946. On the easel stands a por-
trait of Stalin left unfinished at her death.

Diego's bedroom is simply furnished. Above
his bed hangs a portrait photograph of Frida
Kahlo, taken by Nickolas Muray.

Most of the paintings in the dining room are
still lifes by anonymous artists of the 19th
century. The Judas figure in the corner stems
from the artist Doña Carmen Caballero, a
great admirer of Rivera's work.

Frida Kahlo and Diego Rivera in the ABC
hospital in Mexico, 1950
In 1950 Frida Kahlo spent nine months in
hospital. Only after several operations on her
leg and back was she again well enough to
paint for four or five hours a day. A special
easel was mounted on her bed so that she
could work lying on her back.

Pages of Frida Kahlo's diary,
around 1946–54
In 1942 Frida Kahlo began writing a diary,
today one of the most important keys to her
thoughts and feelings. She not only recorded
current events, but reflected back upon her
childhood and youth. She discussed such
topics as sexuality and fertility, magic and eso-
tericism, as well as her mental and physical
suffering. She also captured her moods in
watercolour and gouache sketches.

"I am very worried about my painting, above
all, because I want to turn it into something
useful; until now I have managed simply an
honest expression of my own self, but one
which is unfortunately a long way from serv-
ing the Party. I must struggle with all my
strength to ensure that the little positive that
my health allows me to do also benefits the
Revolution, the only real reason to live."
FRIDA KAHLO

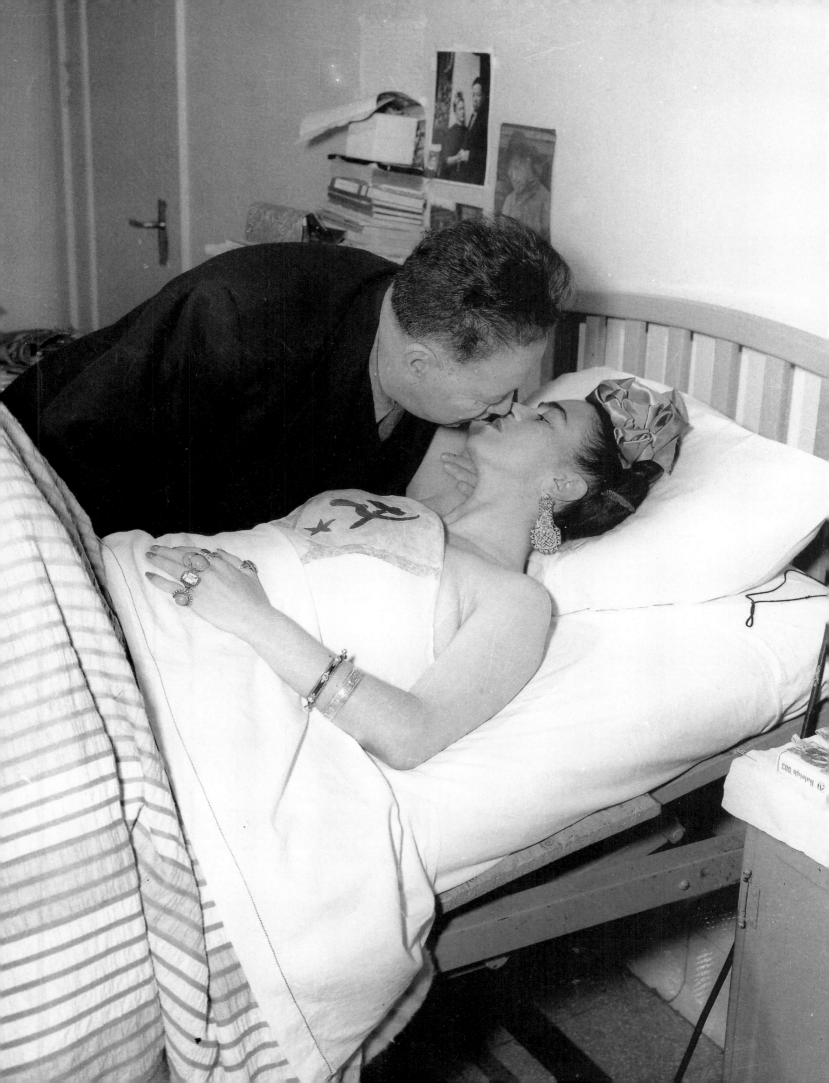

Frida Kahlo 1907-1954: Life and work

1907 Magdalena Carmen Frieda Kahlo Calderón is born on 6 July as the third daughter of Matilde Calderón de Kahlo, Mexican, and Wilhelm Kahlo, German, in Coyoacán, a suburb of Mexico City.

1913 She contracts polio, which leaves her with a slightly crooked right foot. She attends the Colegio Alemán elementary school in Mexico City.

1922 As one of thirty-five girls amongst some two thousand pupils, she attends the Escuela Nacional Preparatoria with a view to studying medicine at university. She admires Diego Rivera at work in her school on the fresco *The Creation*.

1925 On 17 September she is seriously injured in a collision between a tram and the bus in which she and her friend Alejandro Gó-

mez Arias are travelling home from school. She spends a month in the Red Cross Hospital and starts painting during her convalescence. Her only previous artistic tuition has been a few drawing lessons from the commercial printmaker Fernando Fernández, whose studio lay close to her school.

1928 She becomes a member of the Mexican Communist Party (PCM) and meets Diego Rivera again. They fall in love. In his fresco *Ballad of the Revolution*, which he paints in the Ministry of Public Education, he depicts her wearing a red blouse and a star on her breast, distributing weapons for the revolutionary struggle.

1929 On 21 August Frida Kahlo and Diego Rivera (1886–1957) are married. The couple live first in an apartment in the centre of Mexico City and then, while Rivera is exe-

cuting a mural commission, in Cuernavaca. Kahlo leaves the Communist Party when Rivera is expelled from it.

1930 Owing to the incorrect position of the foetus, Frida Kahlo's first pregnancy is terminated at the start of the year. Rivera is offered commissions in the USA, and in November the couple move to San Francisco.

1931 Frida Kahlo meets Dr. Leo Eloesser. He is to become her most trusted medical advisor for the rest of her life. Both the pain and deformity in her right leg increase. In July the couple return briefly to Mexico.

1932 In April the couple move to Detroit, where Rivera has been awarded another commission. After three and a half months, Frida Kahlo's second pregnancy ends on 4 July with a miscarriage at the Henry Ford Hospital. On

Frida Kahlo in a man's suit (left) with members of her family, 1926

Frida Kahlo and Diego Rivera at the time of their weddding, 1928

Frida Kahlo with a wooden sculpture by Mardeño Magaña from her collection, around 1930

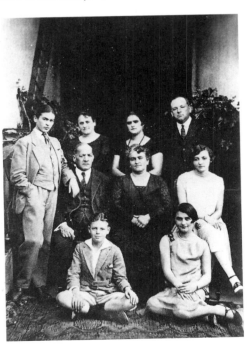

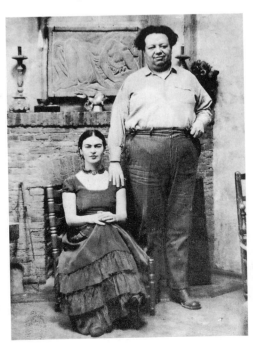

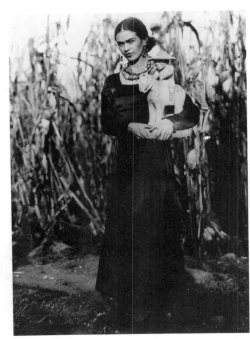

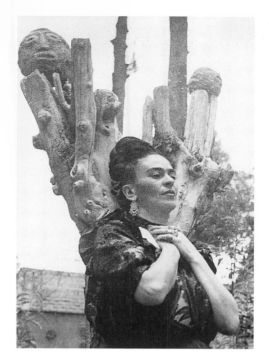

Frida Kahlo in her garden with a pre-Columbian stone mask, around 1950

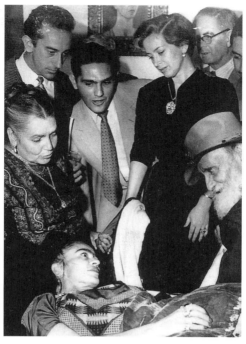

Frida Kahlo at the opening of her exhibition in the Galería de Arte Contemporáneo, 1953

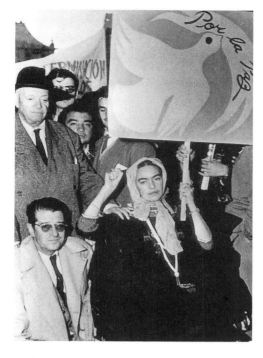

Frida Kahlo at the demonstration against the overthrow of the Guatemalan president by the CIA, 1954

15 September, the artist's mother dies during a gall-bladder operation.

1933 In March the couple move to New York, where Rivera paints a mural in the Rockefeller Center. They return to Mexico at the end of the year and move into a new house in San Angel.

1934 Due to "infantilism of the ovaries", Frida Kahlo's third pregnancy is again terminated at three months. Her right foot is operated on for the first time, and several toes are removed. Diego Rivera has an affair with her younger sister, Cristina.

1935 Frida Kahlo leaves the house in San Angel for several months and takes her own apartment. She meets the American sculptor Isamu Noguchi and has an affair with him. She travels to New York with a number of women friends.

1936 Back in the couple's joint home, she has a third operation on her foot. She becomes actively engaged in a solidarity committee in aid of the Spanish Republicans.

1937 Leon Trotsky and Natalia Sedova arrive in Mexico on 9 January. Frida Kahlo places the Blue House in Coyoacán at their disposal.

1938 André Breton and Jacqueline Lamba arrive in Mexico in April, in order to meet Trotsky. They stay with Guadalupe Marín, Diego Rivera's previous wife, and meet the Kahlo-Riveras. The first solo exhibition of

Frida Kahlo's works is held in October/November in Julien Levy's gallery in New York. It is a great success. She begins an affair with the photographer Nickolas Muray.

1939 She travels to Paris, where she exhibits her works in the Renou & Colle gallery in March and meets the Surrealist painters. Following her return to Mexico, she moves back into the family home in Coyoacán. Frida Kahlo and Diego Rivera are divorced at the end of the year.

1940 In September she travels to San Francisco for treatment from Dr. Eloesser. There, on 8 December, Frida Kahlo and Diego Rivera are married for a second time.

1941 On 14 April Guillermo Kahlo dies of a heart attack. From now on, the Kahlo-Riveras live in the Blue House in Coyoacán. Diego Rivera continues to use the house in San Angel as his studio.

1942 Frida Kahlo starts writing a diary. She becomes a member of the Seminario de Cultura Mexicana.

1943 She is awarded a professorship at the "La Esmeralda" School of Art. After only a few months she is forced by poor health to hold her classes at home in Coyoacán.

1946 She receives a national prize from the Ministry of Public Education for her picture *Moses*. She goes to New York for an operation on her spine.

1948 She rejoins the Mexican Communist Party (PCM).

1950 She undergoes a total of seven operations on her spine and spends nine months in hospital.

1951 Following her discharge from hospital, she is confined to a wheelchair for much of the time. From now on she has to take regular painkillers.

1952 She helps to collect a list of signatures supporting the peace movement; Diego Rivera shows her thus engaged in his mural *The Nightmare of War and the Dream of Peace*.

1953 Lola Alvarez Bravo organizes the first solo exhibition of Frida Kahlo's works in Mexico in her gallery. The artist attends the opening lying in bed. Her right leg is amputated below the knee.

1954 She catches pneumonia, but while still convalescing, and against the advice of her doctors, nevertheless takes part in a demonstration against North-American intervention in Guatemala. On 13 July Frida Kahlo dies in the Blue House.

1958 The Museo Frida Kahlo is opened and presented to the Mexican nation in accordance with the wishes of Diego Rivera, who died in 1957.

List of Illustrations

39
A Few Little Pricks (Unos cuantos piquetitos), 1935
Oil on metal, 38 x 48.5 cm
Mexico City, Collection Dolores Olmedo

40 left
Photo: anonymous, 1938
Collection Museo Estudio Diego Rivera

40 right
Self-portrait dedicated to Leon Trotsky or "Between the
Courtains" (Autorretrato dedicado a Leon Trotski o "Between
the Courtains"), 1937
Oil on canvas, 87 x 70 cm
Washington (DC), The National Museum for Women in
the Arts

41
Photo: Juan Guzmán, around 1942

42 right
Memory or The Heart (Recuerdo o El Corazón), 1937
Oil on metal, 40 x 28 cm
Paris, Collection Michel Petitjean

43 left
Self-portrait with Itzcuintli Dog (Perro Itzcuintli con-migo),
around 1938
Oil on canvas, 71 x 52 cm
Private collection

44
Self-portrait with Monkey (Autorretrato con mono), 1938
Oil on masonite, 40.6 x 30.5 cm
Buffalo (NY), Albright-Knox Art Gallery, Bequest of
A. Conger Goodyear, 1966

45
Self-portrait dedicated to Marte R. Gómez (Autorretrato
dedicado a Marte R. Gómez), 1946
Pencil on paper, 38.5 x 32.5 cm
Private collection

46 above
The Mask (La máscara), 1945
Oil on canvas, 40 x 30.5 cm
Mexico City, Collection Dolores Olmedo

46 below
Photo: Tina Modotti

47
My Nurse and I or I suckle (Mi nana y yo o Yo mamando),
1937
Oil on metal, 30.5 x 34.7 cm
Mexico City, Collection Dolores Olmedo

48
The Dream or Self-portrait, dreaming (I) (El sueño o Auto-
rretrato onírico {I}), 1932
Pencil on paper, 27 x 20 cm
Cuernavaca, Collection Rafael Coronel

48
Hieronymus Bosch
The Garden of Delights (detail)
Oil on wood, 220 x 389 cm
Madrid, Museo del Prado

48
Four Inhabitants of Mexico City (Cuatro habitantes de la
ciudad México), 1938
Oil on metal, 32.4 x 47.6 cm
Private collection

48
Max Ernst
The Nymph Echo, 1936
Oil on canvas, 46.5 x 55.4 cm
Private collection

49
What I Saw in the Water or What the Water Gave Me (Lo
que vi en el agua o Lo que el agua me dio), 1938
Oil on canvas, 91 x 70.5 cm
Paris, Collection Daniel Filipacchi

50
The Suicide of Dorothy Hale (El suicidio de Dorothy Hale),
1938/39
Oil on masonite with painted wooden frame,
60.4 x 48.6 cm
Phoenix (AZ), Phoenix Art Museum, anonymous dona-
tion

51
Portrait of Diego Rivera (Retrato de Diego Rivera), 1937
Oil on wood, 46 x 32 cm
Mexico City, Collection Jacques & Natasha Gelman

52
Self-portrait, drawing (Autorretrato dibujando),
around 1937
Pencil and crayon on paper, 29.7 x 21 cm
Private collection

53
The Two Fridas (Las dos Fridas), 1939
Oil on canvas, 173.5 x 173 cm
Mexico City, Museo de Arte Moderno

54
Self-portrait with Cropped Hair (Autorretrato con pelo cor-
tado), 1940
Oil on canvas, 40 x 27.9 cm
New York (NY), Collection, The Museum of Modern Art,
Gift of Edgar Kaufmann Jr.

56 above
Diego Rivera
Sunday Afternoon Dream in Alameda Park (detail),
1947/48
Fresco on transportable panel, total area 72 m²
Hotel del Prado, today on display in the Pabellon Diego
Rivera in Mexico City

56 below
Two Nudes in the Forest or The Earth Itself or My Nurse
and I (Dos desnudos en un bosque o La tierra misma o Mi nana
y yo), 1939
Oil on metal, 25 x 30.5 cm
Private collection

57
The Dream or The Bed (El sueño o La cama), 1940
Oil on canvas, 74 x 98.5 cm
New York (NY), Collection Selma and Nesuhi Ertegun

58
Photo: Nickolas Muray, 1939
Rochester (NY), International Museum of Photography at
George Eastman House

59
Self-portrait dedicated to Dr. Eloesser (Autorretrato dedi-
cado al Dr. Eloesser), 1940
Oil on masonite, 59.5 x 40 cm
Private collection

60
Self-portrait with Braid (Autorretrato con trenza), 1941
Oil on masonite, 51 x 38.5 cm
Mexico City, Collection Jacques & Natasha Gelman

61
Photo: anonymous, around 1940
Collection CeNIDIAP

62
Thinking about Death (Pensando en la muerte), 1943
Oil on canvas, mounted on masonite, 44.5 x 36.3 cm
Private collection

63
Portrait of Doña Rosita Morillo (Retrato de Doña Rosita
Morillo), 1944
Oil on canvas, mounted on masonite, 76 x 60.5 cm
Mexico City, Collection Dolores Olmedo

64 left
Photo: anonymous, around 1939/40
Rochester (NY), International Museum of Photography at
George Eastman House, Collection Nickolas Muray

64 right
Me and My Parrots (Yo y mis pericos), 1941
Oil on canvas, 82 x 62.8 cm
New Orleans (LA), Collection Mr. and Mrs. Harold H.
Stream

65 left
Self-portrait with Monkeys (Autorretrato con monos), 1943
Oil on canvas, 81.5 x 63 cm
Mexico City, Collection Jacques & Natasha Gelman

66
Self-portrait as a Tehuana or Diego in My Thoughts or
Thinking of Diego (Autorretrato como Tehuana o Diego en mi
pensamiento o Pensando en Diego), 1943
Oil on masonite, 76 x 61 cm
Mexico City, Collection Jacques & Natasha Gelman

67
Diego and Frida 1929–1944 (I) or Double Portrait, Diego
and I (I) (Diego y Frida 1929–1944 {I} o Retrato doble
Diego y yo {I}), 1944
Oil on masonite with shell surround, 26 x 18.5 cm
Mexico City, Collection Francisco and Rosi González
Vázquez

68
The Broken Column, corset (Corsé La columna rota),
around 1944
Oil on plaster cast with straps
Mexico City, Museo Frida Kahlo

69
The Broken Column (La columna rota), 1944
Oil on canvas, mounted on masonite, 40 x 30.7 cm
Mexico City, Collection Dolores Olmedo

70 left
Fantasy (I) (Fantasía {I}), 1944
Crayon and pencil on paper (page of a notebook),
24 x 16 cm
Mexico City, Collection Dolores Olmedo

70 above
Landscape (Paisaje), around 1946/47
Oil on canvas, 20 x 27 cm
Mexico City, Museo Frida Kahlo

70 below right
Without Hope (Sin esperanza), 1945
Oil on canvas, mounted on masonite, 28 x 36 cm
Mexico City, Collection Dolores Olmedo

71 left
Tree of Hope, Keep Firm (Arbol de la esperanza, manténte
firme), 1946
Oil on masonite, 55.9 x 40.6 cm
Paris, Collection Daniel Filipacchi

71 right
Letter to Alejandro Gómez Arias IX, 1946
Pencil on paper, dimensions unknown
Private collection

72
Photo: Nickolas Muray, around 1939
Rochester (NY), International Museum of Photography at
George Eastman House

73
The Wounded Deer or The Little Deer or I am a Poor
Little Deer (El venado herido o El venadito o Soy un pobre
venadito), 1946
Oil on masonite, 22.4 x 30 cm
Private collection

74
Moses or Nucleus of Creation (Moisés o Núcleo Solar), 1945
Oil on masonite, 61 x 75.6 cm
Private collection

75
Sun and Life (El sol y la vida), 1947
Oil on masonite, 40 x 50 cm
Mexico City, Galería Arvil

76
Flower of Life (Flor de la Vida), 1943
Oil on masonite, 27.8 x 19.7 cm
Mexico City, Collection Dolores Olmedo

77
The Love Embrace of the Universe, the Earth (Mexico),
Myself, Diego and Señor Xólotl (El abrazo de amor de El
universo, la tierra {México}, Yo, Diego y el señor Xólotl), 1949
Oil on canvas, 70 x 60.5 cm
Mexico City, Collection Jacques & Natasha Gelman

78
Diego and I (Diego y yo), 1949
Oil on canvas, mounted on masonite, 28 x 22 cm
Chicago (IL), Collection Sam and Carol Williams

80
Self-portrait with the Portrait of Dr. Farill *or* Self-portrait
with Dr. Juan Farill *(Autorretrato con el retrato del Dr. Farill
o Autorretrato con el Dr. Juan Farill)*, 1951
Oil on masonite, 41.5 x 50 cm
Private collection

81
Photo: Gisèle Freund, around 1952

82 above
Living Nature *(Naturaleza viva)*, 1952
Oil on canvas, dimensions unknown
Mexico City, Collection María Félix

82 below
Still life with Flag *(Naturaleza muerta)*, around 1952–54
Oil on masonite, 38 x 58 cm
Mexico City, Museo Frida Kahlo

83 above
Fruit of Life *(Fruta de la Vida)*, 1953
Oil on masonite, 47 x 62 cm
Mexico City, Collection Raquel M. de Espinosa Ulloa

83 below
Still life with Watermelons *(Naturaleza muerta con
sandías)*, 1953
Oil on masonite, 39 x 59 cm
Mexico City, Museo de Arte Moderno

84
Photo: anonymous, 1951/52
Collection CeNIDIAP

85
Marxism Will Give Health to the Sick *(El marxismo dará
salud a los enfermos)*, around 1954
Oil on masonite, 76 x 61 cm
Mexico City, Museo Frida Kahlo

86 left
Photo: anonymous, 1954

86 right
Self-portrait with a Portrait of Diego on the Breast and
María between the Eyebrows *(Autorretrato con el retrato de
Diego en el pecho y María entre las cejas)*, 1953/54
Oil on masonite, 61 x 41 cm
Whereabouts unknown

87 left
Self-portrait with Stalin *or* Frida and Stalin *(Autorretrato
con Stalin o Frida y Stalin)*, around 1954
Oil on masonite, 59 x 39 cm
Mexico City, Museo Frida Kahlo

87 right
Photo: Antonio Kahlo, 1952/53
Collection Fanny Rabel

88/89
Photos: Laura Cohen

90
Diary pages from the years 1946–54
Mexico City, Museo Frida Kahlo

91
Photo: Juan Guzmán, 1950
Collection CeNIDIAP

92 left
Photo: Guillermo Kahlo, 1926

92 right
Photo: Guillermo Dávila, around 1930
Collection Carlos Pellicer López

93 left
Photo: Lola Alvarez Bravo, around 1950

Notes

1 Diary entry, quoted from Hayden Herrera, Frida, A
Biography of Frida Kahlo, London 1989, p. 11
2 Diary entry, quoted from Herrera 1989, p. 12
3 From Salomón Grimberg, in: Helga Prignitz-Poda,
Salomón Grimberg, Andrea Kettenmann, Frida
Kahlo: das Gesamtwerk, Frankfurt/Main 1988, p. 18
4 Diary entry, quoted from Herrera 1989, p. 20
5 From Raquel Tibol, Frida Kahlo. Una Vida Abierta,
Mexico City 1983, p. 48 f.
6 From Antonio Rodríguez, Frida Kahlo heroína del
dolor, in: Hoy, Mexico City, 9 February 1952
7 From Antonio Rodríguez, Una pintora extraordina-
ria, in: Así, Mexico City, 17 March 1945
8 Tibol 1983, p. 96
9 From Homenaje a Frida Kahlo, in: Mexico City,
no.330, 17 July 1955, p. 1; quoted from Herrera
1989, p. 74 f.
10 Lola Alvarez Bravo, in: Karen & David Crommie,
The Life and Death of Frida Kahlo, 16 mm docu-
mentary film, San Francisco 1966
11 From Diego Rivera/Gladys March, My Art, My Life.
An Autobiography, New York 1960, p. 169 ff.
12 Tibol 1983, p. 95f.
13 Bambi, Frida dice lo que sabe, in: Excelsior, Mexico
City, 15 June 1954, p. 1; quoted from Herrera 1989,
p. 109
14 Diego Rivera, in: Fashion Notes, in: Time, New
York, 3 May 1948, p. 33f.
15 Tibol 1983, p. 97
16 Herrera 1989, p. 138
17 Ibid., p. 142f.
18 Tibol 1983, p. 53; quoted from Herrera 1989, p. 119
19 Herrera 1989, p. 131
20 André Breton, Frida Kahlo, from: André Breton, Sur-
realism and Painting, London 1972, p. 143 (trans-
lated by Simon Watson Taylor from the original
French edition, Le Surréalisme et la Peinture, Paris
1945)
21 Bertram D. Wolfe, Rise of another Rivera, in:
Vogue, New York, vol. 92, no. 1, Oct/Nov 1938,
pp. 64, 131
22 Herrera 1989, p. 225
23 From Bambi, Frida Kahlo es una Mitad, in: Excelsior,
Mexico City, 13 June 1954, p. 6; quoted from Her-
rera 1989, p. 226
24 Herrera 1989, p. 291f.
25 Ibid., pp. 242, 245f.
26 Ibid., p. 250
27 MacKinley Helm, Modern Mexican Painters, New
York 1941, p. 167
28 Dr. Henriette Begun, in: Raquel Tibol, Frida Kahlo,
Frankfurt/Main 1980, p. 141
29 Herrera 1989, p. 286
30 Rivera/March 1960, p. 242f.
31 Herrera 1989, p. 307
32 Ibid., p. 332
33 From a letter to Alejandro Gómez Arias of 30 June
1946, Gómez Arias Archive
34 From a letter to Eduardo Morillo Safa of 11 October
1946, quoted from Rosario Camargo E., Dos Cartas
Frente al Espejo, in: México desconocido, Mexico
City, no. 98, March 1985, p. 47
35 This and the following quotation from Frida Kahlo,
Retrato de Diego, in: Hoy, Mexico City, 22 January
1949
36 Diary entry quoted in Hayden Herrera, Frida: Una
Biografía de Frida Kahlo, Mexico City, 1985 (7th
edition 1988), p. 314
37 Tibol 1983, p. 63
38 Carlos Pellicer, in: Museo Frida Kahlo. Catalogue of
the collection (Fideicomiso Diego Rivera, ed.),
Mexico City, undated (c.1958, on the opening of the
museum), p. 8
39 Tibol 1983, p. 63 f.
40 Quoted after Judith Ferreto, Frida Kahlo's nurse, in:
Crommie 1966
41 Tibol 1983, p. 132
42 Lola Alvarez Bravo, in: Crommie 1966
43 Rivera/March 1960, p. 284
44 Tibol 1983, p. 64; quoted from Herrera 1989, p. 420
45 Rivera/March 1960, p. 285
46 Herrera 1989, p. 431

The publishers wish to thank the museums, galleries,
collectors and photographers who supported and encour-
aged us in the preparation of this book. Above all we
would like to thank the photographers Rafael Doniz of
Mexico City and Salomón Grimberg of Dallas for their in-
valuable help. In addition to the individuals and institu-
tions named in the list of illustrations, the following ac-
knowledgements are also due: Ben Blackwell (23);
Bokförlaget A, Stockholm (75); CeNIDIAP (8 above, 11,
15 right, 21 below, 22, 40 left, 56 above, 61, 84, 86 left,
87 right, 91, 92 left, 93 left); Christie's, New York (33);
Jorge Contreras, provided by the Centro Cultural Arte
Contemporáneo, Mexico (16, 65 left, 66); Isidore Ducasse
Fine Arts (71 left); Rafael Doniz (1, 6, 8 below, 10, 12
above, 13, 14 right, 18 above, 19, 25, 27, 28 below right,
29 below right, 31, 36, 37, 39, 45, 46 above, 47, 48
above right, 53, 59, 60, 62, 63, 67, 68, 69, 70 left, 70
above, 70 below right, 71 right, 74, 76, 80, 82 below, 83
below, 85, 87 left); Rafael Doniz Archive (12 below [pro-
vided by Pater Rubén García Vadillo], 14 left [provided
by MUNAL], 41, 92 right); photos courtesy Salomón
Grimberg (17, 18 below, 26, 28 above left, 28 below left,
29 above right, 29 below left, 32, 34 above, 34 below, 35
below, 38 below, 42 right, 43 left, 51, 52, 56 below, 57,
64 right, 78, 82 above, 83 above, 90); Salvador Lutteroth
(77); Olav Münzberg, Berlin (20); Mali Olatunji (54);
Sotheby Parke Bernet, photo courtesy Salomón Grimberg
(73); Sotheby's, New York (49, 86 right).